BRITAIN'S HERITAGE

Art Deco

Oliver Green

AMBERLEY

Acknowledgements

Most of the modern photographs in this book were taken by Oliver Green between 2008 and 2018. Unattributed pre-war postcard images are from the author's personal collection. All other image sources are acknowledged in the captions and are reproduced with thanks.

The cover photograph shows the empty shell of Battersea Power Station, London, in 2012. This is the largest art deco structure in Europe, built with brick cladding on a steel frame to house two giant power stations in one building. Construction was in two phases, Battersea A becoming operational in 1933–5 and Battersea B in 1953–5. The two stations closed in 1975 and 1983, lying listed but derelict for more than thirty years. Restoration and renovation of the entire site began in 2013 with the iconic 'temple of power' at the heart of a new residential and commercial quarter which will include a London headquarters for Apple inside the former power station. (Alberto Pascual/Wikipedia Creative Commons)

The Author

Oliver Green is a museums consultant, historian and lecturer. He is the former Head Curator of the London Transport Museum and is now its Research Fellow and a trustee of the LTM Friends. He has written and edited several books on transport, art and design history including *Frank Pick's London: Art, Design and the Modern City*, published by the Victoria & Albert Museum (V&A).

First published 2018

Amberley Publishing
The Hill, Stroud
Gloucestershire, GL5 4EP

www.amberley-books.com

Copyright © Oliver Green, 2018

The right of Oliver Green to be identified as the Author of this work has been asserted in accordance with the Copyrights, Designs and Patents Act 1988.

ISBN 978 1 4456 7913 6 (paperback)
ISBN 978 1 4456 7914 3 (ebook)

British Library Cataloguing in Publication Data.
A catalogue record for this book is available from the British Library.

Printed in the UK.

Contents

1

Introduction: Art Deco and Modernism 1925–40

Art deco is a design style characterised by a mixture of geometric, sleek and elegant decorative forms that appeared in the 1920s, became popular in the 1930s and disappeared almost completely with the outbreak of the Second World War. It was never a clear movement with a specific style, purpose or manifesto but a blend of various sources and influences brought together in different combinations. The boundaries of art deco are blurred and indeterminate and there is no clear definition as to what it includes. It began as lavish private decoration for the few and became a popular public style for all in under twenty years.

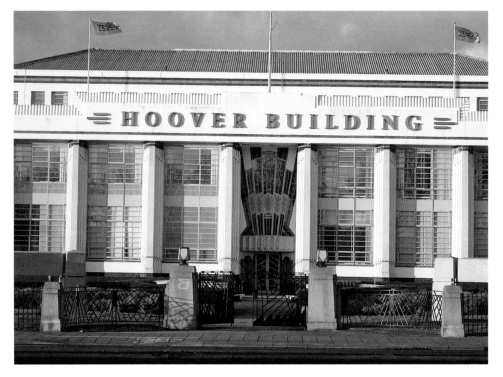

The Hoover factory on the Western Avenue, Perivale, London, by Wallis, Gilbert & Partners, 1931–5. This is probably the best known example of art deco architecture in Britain, with its dramatic Egyptian-style façade. Nikolaus Pevsner's 1951 *Buildings of England* volume describes it as 'perhaps the most offensive of the modernistic atrocities along this road of typical bypass factories'. Times and opinions change. It is now protected as a Grade II* listed building and has recently been converted into apartments after many years lying empty.

The common thread between art deco's changing forms in architecture and design was a wish to appear modern. Deco broke away from traditional decorative styles by using new shapes, bright colours and mechanised production that looked to the future rather than the past for inspiration. Its earliest manifestations can be traced to various European cities just before the First World War, but it was not until the mid-1920s that it began to spread from a central focus in Paris. Art deco, in all its variety, seemed to capture the essence of modernity and the sense of being in touch with the future, something that appealed across classes and across nations after the trauma of the First World War.

Art deco shape-shifted from being a luxury style associated with Parisian high fashion, lavish interior design and ornamentation to the silver screen decor of Hollywood, leisure activities for all at the seaside, and modern machine living in home, office or factory. On the way it also became, with the adoption of streamlining, a style that perfectly suited rapid modern transport and communication systems from airliners to radios.

For all its love of modernity, art deco was also eclectic and plundered the past for bold and 'exotic' decorative designs and motifs ranging from Ancient Egypt and West Africa to the Aztec and Mayan cultures of Central America. Among the many contradictions in art deco style is this almost eccentric combination of historicism and high modernity, which could owe as much to popular fashion as future foresight.

Art deco takes its name from the first great world's fair devoted to the decorative arts, held in Paris between April and October 1925. The exhibition's full title was L'Exposition Internationale des Arts Décoratifs et Industriels Modernes. The abbreviation art deco was only adopted in the mid-1960s, when interest in the pre-war style was first revived. It quickly became a catch-all description for the distinctive and showy new styles in architecture, ornament and interior decoration first displayed together in Paris forty years earlier.

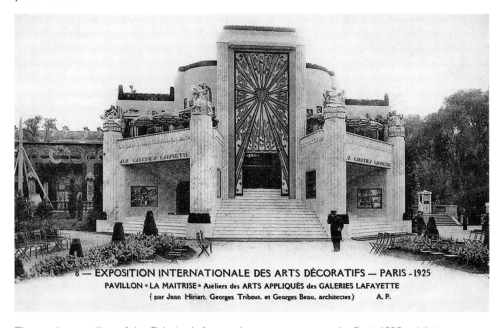

8 — EXPOSITION INTERNATIONALE DES ARTS DÉCORATIFS — PARIS - 1925
PAVILLON • LA MAITRISE • Ateliers des ARTS APPLIQUÉS des GALERIES LAFAYETTE
(par Jean Hiriart, Georges Tribout, et Georges Beau, architectes) A. P.

The art deco pavilion of the Galeries Lafayette department store at the Paris 1925 exhibition.

In the 1920s these styles were collectively known as 'jazz moderne' or 'modernistic', early applications of new decorative forms to traditional and expensive products like designer furniture and jewellery. Art deco soon took on a much wider and less elitist relevance, linked to a growing consumer market encouraged by the boom in mass leisure activities. By the 1930s the adoption of artificial materials like chrome and bakelite, suitable for machine-made mass production, as well as the stripped down streamlined look were further developments promoted by industrial designers in the USA, all within the loose deco umbrella. Today art deco is still used as a generic term for a distinctive, novel and wide-ranging set of design forms popularised across the world in the inter-war period.

Paris in 1925 was not the starting point of art deco but it was the first time that different and diverging aspects of modernism that had been growing since the early 1900s were bundled together in a single, disparate international showcase. As such the exhibition gave a dramatic boost to new developments and thinking, which were widely disseminated over the next fifteen years with varying results. Traditional design elements that followed well-established classical rules continued to dominate, but in a very short period various distinctive deco features crept into the mainstream. The trickle down of new ideas, production methods and technology brought rapid change that would not be seen again until the digital revolution at the end of the twentieth century.

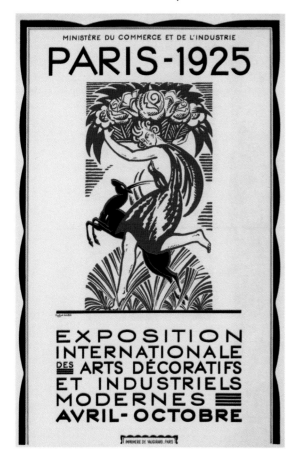

Poster for the 1925 art deco exhibition in Paris by Robert Bonfils. (Getty Images)

Did you know?

Streamline Moderne is a late form of art deco that emerged in the 1930s, first developed by industrial designers in the USA. They stripped art deco design of its ornament and introduced the aerodynamic pure-line concept of motion and speed developed from scientific thinking. It was both a reaction to the early extravagance of art deco and a reflection of austere economic times after the Wall Street crash of 1929 and the Great Depression that followed. The sharp angles of early art deco were replaced with simple curves. Exotic goods and stone were succeeded by concrete and glass. Cylindrical forms and long horizontal window lines were introduced in architecture, and aerodynamic shapes were refined for vehicles.

It was not adopted universally, but the various new forms of art deco style had a sharp impact on the look of urban streetscapes and interiors all over Britain in the 1930s. In architecture art deco or 'jazz moderne' forms were particularly fashionable for new cinemas, hotels and department stores, though less so for residential properties. Designers found it difficult to sell art deco and modernism in the home beyond the occasional exotic decorative ornament.

Art deco felt more appropriate in a leisure environment like a seaside resort or an open air lido. It aimed to offer you the glamour of the French Riviera or Manhattan, places you could never afford to visit in person. Meanwhile, the more extreme elements of deco were mocked mercilessly by established architects, designers and social critics as either vulgar or pretentious. It was despised and patronised by many of the professionals but the public loved it as the backdrop to their hard-earned leisure time.

Not surprisingly, the style was more pervasive in commercial and decorative art, where attention-grabbing impact and selling is all-important. It was far less significant in fine art, and there are very few painters whose style of modernism can be characterised as deco. Art deco was ideal for book jackets and magazine advertising, for murals, neon signage and posters, often promoting

The Carlton, Islington, one of the first cinemas in London to be built in the art deco Egyptian style. It was designed by George Coles in 1930.

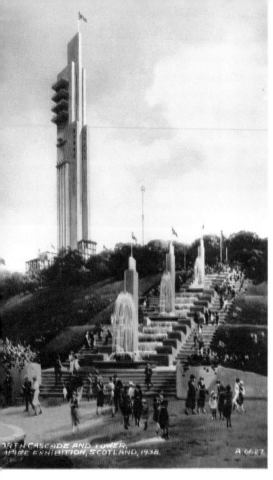

ORTH CASCADE AND TOWER,
PIRE EXHIBITION, SCOTLAND, 1938. A.6627.

Left: Modernism cut short in Scotland. The futuristic tower of the 1938 Empire Exhibition in Glasgow was demolished when the exhibition closed and the country prepared for war. It was designed by Thomas Tait, architect of the first group of art deco houses in England at Silver End, Essex, only twelve years earlier.

Below: The Tinside Lido on the seafront at Plymouth, opened in 1935 and recently restored to its original art deco glory. (Nilfanion/Creative Commons)

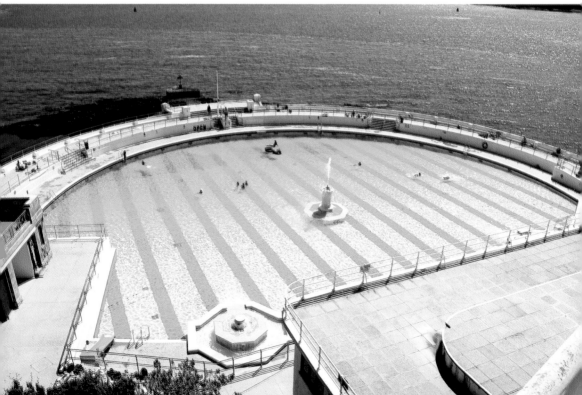

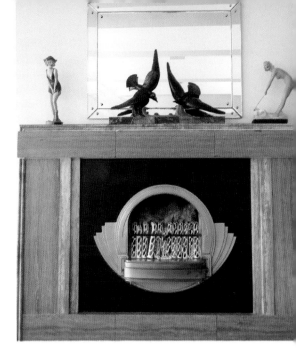

An art deco gas fire and 1930s period ornaments at the Burgh Island Hotel, Bigbury-on-Sea, Devon.

leisure activities from holidays to sport. Its invocation of a modern, fast-moving but comfortable machine-age lifestyle inevitably shaped transport design as streamlined style was adopted in the 1930s for trains, ships and airliners. In the domestic environment the use of chrome and plastics like bakelite brought streamlining to objects that would never actually move at all: electric irons, heaters, lamps, mirrors, and clocks all went through a brief modernistic deco phase.

Everyone soon came into contact with some aspect of deco, whether visiting a new super-cinema, reading a magazine advertisement or buying a new wireless set. Deco design, even on fairly cheap, mass produced products, gave an aspirational feeling of up-to-date luxury, which was very appealing in troubled times. It came to an equally sudden end all over Europe with the outbreak of the Second World War, when its sleek and expensive-looking appearance seemed instantly inappropriate on a Continent plunged into wartime austerity.

Deco only continued to dominate as the prevalent style of new architecture and design in the USA in the early 1940s. By 1945 it had largely gone there too and was hardly seen again anywhere after the Second World War until a few elements of retro-deco were revived in the 1980s. Looking back from the twenty-first century, art deco now looks like the most influential but also the most short-lived design style of the last century, and yet its features still defy precise and agreed definition.

Did you know?

There were fierce debates about the quality of modernism in architecture and design long before it was generically referred to as art deco. Traditionalists considered it superficial and tasteless at the time, unworthy of any classically trained architect or designer, while purists for more refined, stripped down 'international modern' design dismissed the flashy, over-decorative end of deco as useless and impractical, fit only for dressing up cinemas and factories.

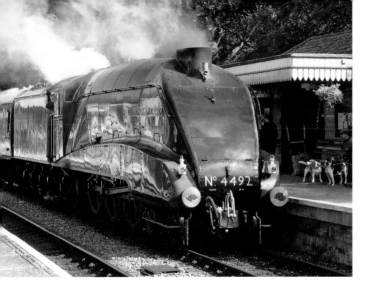

The triumph of streamlining: an LNER A4 Pacific designed by Sir Nigel Gresley, introduced on east coast express trains in 1935. This survivor has been restored to working order for heritage train operation.

The 1925 Exhibition

The Paris 1925 exhibition was planned specifically as a celebration of modernism in the decorative arts and the programme announced that it was 'open to all manufacturers whose products are artistic in character and show clearly modern tendencies.' There was no clear definition of what 'modern tendencies' might be and 'modernism' was already heading in some different and contradictory directions. Art deco quickly became a stylistic mash-up of heritage and modernity, exclusive crafted materials and mass production by machine, a Janus-like looking backwards and forwards at the same time.

For the French government, the exhibition's purpose was less about art than commerce. Despite the organisers' proclamations of internationalism, the fair was also a clear diplomatic and political statement about reasserting the primacy of French artistic culture in the difficult post-war world. The exhibition was also intended to honour the victorious Allied countries of the First World War, which meant inviting the new Soviet Union to participate but not the defeated Germany. Despite this significant omission, Austria took part and showcased the modern work of the progressive German architect and industrial designer Peter Behrens, whose follower Walter Gropius had founded the radical Bauhaus art school in 1919.

Although he did not take part in the Paris exhibition, Gropius was to be one of the leading figures in the spread of a simplified international modern style of architecture and design that moved away from the highly decorated luxury features that dominated French art deco in 1925. There was already division among practitioners in France, with more radical modernists like the French/Swiss architect Le Corbusier advocating an end to useless decoration altogether and a more scientific approach to design. His first and most influential book, *Towards an Architecture*, published in 1923, contained his famous maxim that the modern house must be 'a machine to live in'.

The simple pavilion that Le Corbusier designed for the 1925 exhibition was intended to represent the apartment of the future, 'a cell within the body of the city' based on standardised mass production. It could not have been further in principle or purpose from the elaborate decoration of the exhibition's sponsored department store pavilions nearby which showcased expensive retail products. Nevertheless, both fit clearly under the art deco umbrella. It was all about *looking* modern and the simplified forms of younger designers intent on moving away from tradition with flat roofed houses, sharp angles and strong horizontals were heading in a radical new direction.

There was an unfortunate misunderstanding with the United States government, which declined to take part in the Paris show. The US Secretary of Commerce and future president Herbert Hoover explained to the organisers that there was no modern art in the USA, and therefore no US pavilion was offered. The Americans' mistake about the exhibition's purpose was recognised shortly afterwards, but not in time to participate. Ironically, it was in the USA that a development of *le style moderne* was to flourish only a few years later as art deco morphed into the streamlined modern style of the latest American trains, airliners and skyscrapers in the 1930s.

Did you know?

Britain did participate in the Paris 1925 exhibition, with a modest and unexceptional display, and a rather curious design of pavilion, but at the time the country was still more concerned with its own very large British Empire Exhibition at Wembley in north-west London. This had opened in 1924 and continued for a second season the following year. Wembley was more akin to a trade exhibition specifically designed to promote the products and benefits of the British Empire to the great British public. There were no progressive cultural or design surprises. Art and industry were kept apart in separate exhibition halls, and there was little attempt to promote any 'modernistic' architecture or applied art and design except in some of the publicity. There was nothing novel or forward-looking in British design at the time and the first strands of modernism that might later be described as art deco in style came from commissions by a handful of individuals in Britain who were aware of new trends on the Continent and in some cases through the input of European designers working in the UK.

When a British government report by the Department of Overseas Trade on the UK contribution to Paris 1925 was published two years later, it was criticised retrospectively as being 'very stolid and unimaginative'. The writers found in it a lack of 'living initiative and adventure' which was still evident in the stolid nature of British design in 1927. Progress was slow, but strains of modernism were filtering through from the Continent.

Michelin House in South Kensington, planned in 1910 as the UK head office for the French tyre company, is a proto-deco design on a concrete frame. In 1985 it was purchased and renovated by designer retailer Terence Conran and publisher Paul Hamlyn, creating an oyster bar, restaurant and a large retail and office complex.

Britain before Modernism

Even before the First World War a few highly individual design projects in Britain exhibited some of the characteristics of art deco well in advance of its flowering in the mid-1920s. An outstanding, quirky example that still survives on the Fulham Road in London is Michelin House, planned in 1910 as the UK head office and service depot of the French tyre company by its engineer François Espinasse. This is both a distinctive early visual reflection of the new spirit of speed and modernity that art deco later came to symbolise, and a triumph of modern engineering construction. The innovative concrete frame of the building took only five months to put up and was clad in brick and bright white tiles with coloured panel views of cars and cycles racing along on Michelin treads. It was an early crossover between an office workplace and a motoring service facility, carefully dressed up to suit this upmarket residential district of the capital.

Another interesting precursor of art deco in Britain was the last completed architectural work of Charles Rennie Mackintosh, who remodelled the Northampton home of engineer and modelmaker Wenman Bassett Lowke in 1916. Mackintosh fashioned a dramatic new interior for 78 Derngate, hidden behind the conventional façade of a nineteenth-century town house, apparently without ever visiting the site. The bold geometric wall decoration of the main rooms, now restored and opened as a museum, certainly prefigure some characteristic features typical of later art deco, though they also introduce design motifs first seen in the Vienna Secession movement of the early 1900s. Does this final work reflect Mackintosh as a pioneer British modernist or is the interior design simply a late flowering in the UK of a decorative style borrowed from turn of the century Vienna? Michelin and Derngate were both idiosyncratic personal projects that were not emulated elsewhere and had little if any influence on design trends in Britain, where safe and conservative styles still dominated in the early 1920s.

Before the war there had been some admiration and even envy in Britain for the apparent progress in Germany of moves to bring modern industrial design and manufacture together. The Deutscher Werkbund, created in 1907, was an alliance of artists, craftworkers, architects and manufacturers hoping to integrate progressive design reform across the country. The Werkbund's membership and influence grew rapidly, culminating in a major international exhibition at Cologne in May 1914 which was curtailed by the declaration of war a few weeks later.

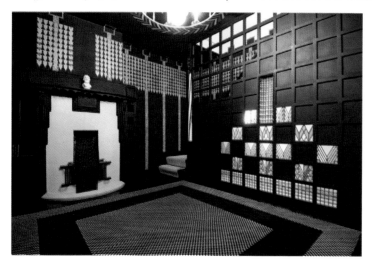

The restored interior of 78 Derngate, Northampton, dramatically redesigned by Charles Rennie Mackintosh for engineer and modelmaker Wenman Bassett Lowke, 1916. The bold geometric wall decoration both prefigures art deco and revives the style of 1900s Vienna. (78 Derngate)

British advocates of design reform who had followed German progress now viewed it with some alarm as a threat to the pre-eminence of British industrial production in the conflict. In 1915 a British equivalent of the Werkbund, the Design and Industries Association, was set up by a group of leading UK designers, art college tutors, architects, retailers and industrialists.

The DIA was committed to raising the standards of British design and industry across the board under its banner of 'fitness for purpose'. Early members included leading design manufacturers and retailers like Wenman Bassett Lowke, Ambrose Heal and Gordon Selfridge, Frank Pick of the London Underground, printer Harold Curwen, architects Charles Holden and Cecil Brewer and designers Gregory Brown and Harold Stabler.

Early Modernism in the UK

But in practice, it was not the DIA that brought modernism to Britain. When the war ended the mission to integrate applied art with industry, commerce and education remained a focus of discussion, but there were more talkers and writers than doers in the DIA. It had little influence on government policy and even less on design education and commercial industry. Novel approaches to architecture and design in the early 1920s still came from individual initiatives rather than any national or collective policy, and only one new building was directly influenced by European modernism. This was another personal project by the irrepressible Bassett Lowke, who purchased a modest plot on the edge of Northampton and commissioned for himself the first art deco house in England, to replace his town centre home in Derngate.

Bassett Lowke had hoped to employ Mackintosh again, but after the war the Scottish architect effectively retired to the south of France and was no longer available. Unable to find another suitable modernist in Britain, Bassett Lowke was impressed by the 'simple, straightforward and modern' work of the German architect Peter Behrens, which he had only seen in a magazine. It was a bold and impulsive decision, taken at a time when using a progressive German designer for a house in the Midlands was considered eccentric and controversial. The British architectural establishment did not quite know what to make of it.

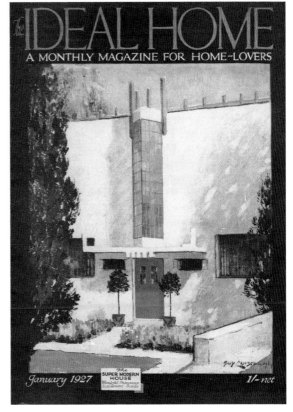

New Ways, the first art deco house in Britain, featured on the cover of *Ideal Home* magazine, January 1927. It was designed by Peter Behrens for Wenman Bassett Lowke in Northampton.

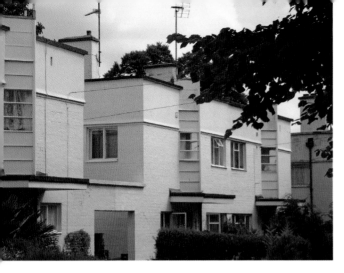

Houses at Silver End in Essex by Thomas Tait, designed for Crittall's model village. Tait's designs were closely influenced by Behrens' New Ways, and Silver End became the first art deco settlement in England, every building effectively advertising Crittall's metal windows.

Behrens was instructed to incorporate part of Mackintosh's interior design from Derngate in the modest white, flat-roofed detached house which rose up incongruously on a suburban plot between two very conventional large Edwardian villas. The *Architectural Review* seemed unable to decide about the house, New Ways, and ended up mystified and patronising. To their reviewer it was 'amusing', 'somewhat bizarre' and 'most cosmopolitan'.

The first offspring of New Ways was Silver End, a workers' settlement in rural Essex planned by Francis Crittall in 1926 as a model village to house the workforce at his booming metal window factory nearby. Crittall's architect, Thomas Tait, took the basic design of Behrens' New Ways and applied it to a whole garden village. For the first time in Britain, the characteristic deco features of white houses with flat roofs, stylised zigzag patterns and metal window frames were applied to a privately built new town. 'I saw a pleasant village of a new order,' wrote the paternalistic Crittall, 'a contented community of Crittall families enjoying the amenities of town life in a lovely rural setting.'

In a sense Crittall was using a similar approach to earlier industrialists and planners who had set up their own managed workers' communities, such as Lord Leverhulme with his Port Sunlight development on Merseyside, and garden cities such as Letchworth and Welwyn in Hertfordshire. The difference was really one of style. All the earlier examples were novel developments but based on traditional designs for housing and community buildings. Silver End, through Thomas Tait's work, was the radical application of modernist European design for an entire new community.

Did you know?

Silver End was the first and only art deco town in Britain. It was also a great showpiece for the Crittall company's products. Within a few years Crittall metal windows would become a key feature of modern building design in Britain, and it is estimated that by 1935 they were being fitted to 40 per cent of all new domestic and commercial buildings in the country. The curved 'Suntrap' design, which was only possible with a pre-fabricated metal frame and could not be reproduced in wood, was particularly popular and emblematic of art deco architecture.

Going Underground

Another pioneer commissioner of modern design in Britain who sought inspiration at the Paris 1925 show was Frank Pick, then Assistant Managing Director of the London Underground. Pick had already built a reputation for the Underground by commissioning dynamic poster work to promote Tube travel and bus excursions. His company was now moving ahead rapidly with new infrastructure and engineering projects. Pick was determined to develop a consistent modern approach to this based on the DIA's creed of 'fitness for purpose'. The next Underground extension, a new line south of the river from Clapham to Morden, had to be functional, look good and work well.

Pick visited Paris twice but could find nothing there in new European architecture and design that felt at all suitable for the Tube. Back in London he turned to a fellow DIA member with similar views, the architect Charles Holden, who in just a few weeks came up with a simple but radical reworking of the street entrance to the Tube that could be repeated in different alignments at all seven new stations from Clapham South to Morden. As Pick wrote excitedly to a DIA colleague, 'we are going to build our stations upon the Morden extension to the most modern pattern ... we are going to represent the DIA gone mad, and in order that I may go mad in good company, I have got Holden to see that we do it properly'.

Clapham South Underground station entrance by Charles Holden, 1926. The Morden line stations were a radical departure from earlier Tube station design.

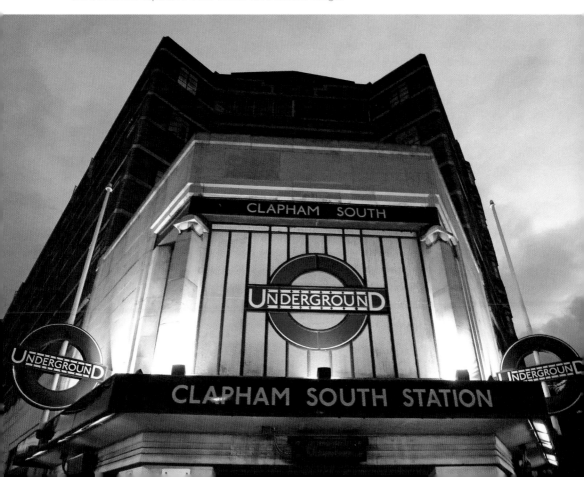

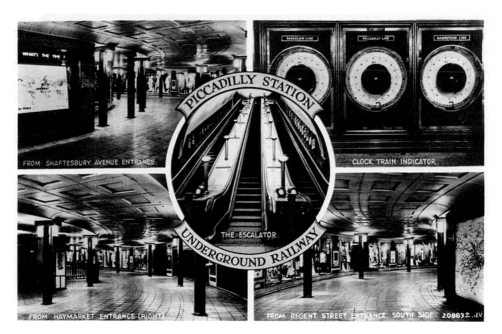

Postcard of the rebuilt Piccadilly Circus station, which quickly became one of the glamorous sights of London when it opened in 1928. (Image from the London Transport Museum)

These modest white Portland stone and glass kiosks stood out from the existing High Street brickwork of south London by day and were floodlit at night, dressed in Edward Johnston's lettering over the red and blue roundel symbol of the Underground. Here in 1926 was the first overall expression of what was soon to develop into the essential 'look' of London Transport and the city's visual identity, a distinctive design that appeared all over town and remains in place to this day.

Pick was so delighted with the Morden line stations that he immediately commissioned Holden to work on two major showpiece projects at the heart of the city, one below and the other above ground. At the rebuilt Piccadilly Circus station, Holden transformed what might otherwise have been a bleak engineer's hole in the ground into a welcoming public space at the heart of London. The new circular booking hall directly below the road junction felt like an extension of the high-class shopping streets above, with display showcases, marble and bronze fittings and stylish decoration.

The environment was nothing like a traditional railway station, and appropriately it was opened by the Mayor of Westminster in December 1928 by switching on a special art deco lamp connected to the new escalators in the centre of the concourse. The first passengers could then glide down to the platforms under a giant mural with an illustrated world map showing London at the heart of the British Empire.

The second major project in central London, built at the same time as Piccadilly, was a giant new head office for the Underground at 55 Broadway. When completed in 1929, this was the tallest office building in Westminster, rising to a central tower ten stories above St James's Park station. Holden came up with an ingenious cruciform plan for the difficult triangular site over the station. It gave space for an entrance to the station and the office block from the street on both

Did you know?

Overseas visitors were particularly impressed with Piccadilly Circus as a prime example of well-designed urban sophistication. The renowned Danish town planner Steen Eiler Rasmussen called it 'an excellent illustration of what the Underground has done for modern civilisation'. He considered it one of the finest examples of new architecture in London, better than anything above ground. Visiting Soviet engineers preparing to build the Moscow Metro reported back to Nikita Khrushchev, their project leader, who in turn persuaded Stalin that they should use the London Underground as the model for their own system.

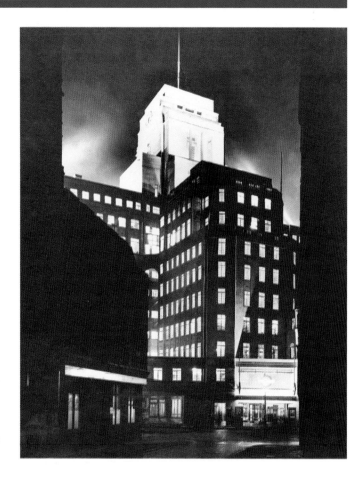

A floodlit night view of Holden's Underground headquarters at 55 Broadway, soon after completion in 1929. This was the first Manhattan-style skyscraper in London and the tallest building in Westminster when it opened. (© TfL from the London Transport Museum collection)

sides of the building. By stepping back the wings up to the tower, all office floors had maximum daylight with fast electric lifts in the centre giving rapid access to all floors.

This was London's first American-style modernist skyscraper, though modest in height compared to the towers then going up in Manhattan such as the Chrysler and Empire State Buildings. Holden commissioned several decorative sculptures for the building exterior by

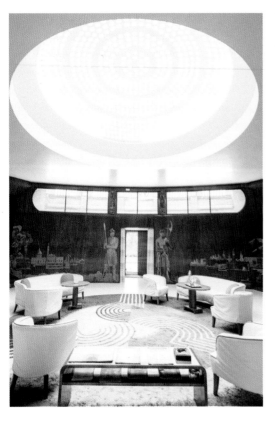

The glamorous interior of Eltham Palace in south-east London, completed for millionaires Stephen and Virginia Courtauld in 1936. It is now managed by English Heritage, who describe their showpiece period property as 'an eclectic mix of art deco, ultra-smart ocean liner style and cutting-edge Swedish design'. (Getty Images)

leading modernist artists including Eric Gill, Henry Moore and, controversially, Jacob Epstein. The two large Epstein figures at first floor level, *Night* and *Day*, were criticised in the popular press as primitive and indecent, but the building was awarded the Royal Institute of British Architects' (RIBA) London Architectural Medal in 1929.

It was the first formal recognition in the UK of a successful modernist structure designed by a British architect and marked the start of a brief decade of new design where work in this country caught up with more rapid progress in Europe, particularly in Germany and France. Today, 55 Broadway is a Grade I listed building with the same statutory heritage protection as the much older Westminster Abbey and Houses of Parliament, just down the road.

It was still early days for UK modernism in the late 1920s, and although conservative styles still dominated, there were suddenly a growing number of interesting departures from tradition. In the space available here, these new trends in art deco and modernism are shown primarily through visual images, divided into themes and design types. It was a mixed pattern over the next decade when striking developments took place which struck out, not always successfully, from the mainstream. That sudden contrast between old and new, which was often highlighted in developments between the wars, is a particularly characteristic feature of the art deco years. There is one fascinating example of an attempt to bridge traditional English architectural styles with contemporary art deco, hidden away in the suburbs of south-east London. The wealthy Stephen Courtauld and his wife Virginia took on the Crown lease of Eltham Palace in 1933, planning to restore the medieval hall built by Edward IV and link it to a large new domestic residence. Their new house had a conservative Wrenaissance exterior and perhaps the most extravagant art deco interior to be completed in Britain, an extraordinary combination.

When the work was finished in 1937 *The Times* described it as 'an admirably designed but unfortunately sited cigarette factory'. It is certainly a curious mixture of styles, but the lavish art deco interior is stunning. Eltham Palace is now managed by English Heritage, who have recently carried out extensive restoration of the property. It is open to the public, so you can judge the results of the Courtaulds' elaborate project for yourself.

2

Graphics and Advertising

There was a productive cross-over in the 1920s between avant garde art and design and the burgeoning commercial world of advertising. A new British trade and advertising journal, *Commercial Art*, appeared in 1922 and soon became the key promoter for the best in modern advertising, with high-quality colour plates and features on the latest developments across Europe and the USA. It was quickly evident that the most progressive work was coming from France, Germany and Austria, while the general run of press advertising and posters in Britain remained bland and conservative.

Art deco drew on many sources and the stylised images of avant garde art movements such as cubism, futurism and constructivism were drawn into the development of commercial art, beginning in Paris and only really spreading to London after 1925. New ideas were communicated more quickly in printed images than through costly infrastructure, but innovation still took time and was only promoted by a few more progressive advertisers like the London Underground and some of the department stores.

New advertising agencies like Crawfords and the fashion magazine *Vogue* drew on emerging illustrative styles from Europe which were filtered into the mainstream in Britain as 'Continental chic'. Crawfords had a Berlin branch as well as a London office and its design director Ashley Havinden was quick to introduce distinctive European styles in their advertising work. The early work of prominent modernists in Britain such as the American poster artist Edward McKnight Kauffer, who moved here from France during the First World War, was much admired but rarely imitated in the 1920s. Kauffer became almost a one-man advocate for what he claimed was a 'scientific' approach to advertising designed to grab the viewer's attention with stylised graphics and lettering rather than simply to illustrate the product or service. Kauffer's distinctive style was extended from posters to book covers, illustrations, publicity work and theatre sets.

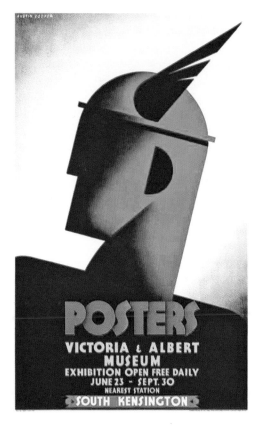

An art deco poster by Austin Cooper advertising the Victoria & Albert Museum's first major exhibition of poster art in 1931. (©TfL from the London Transport Museum collection)

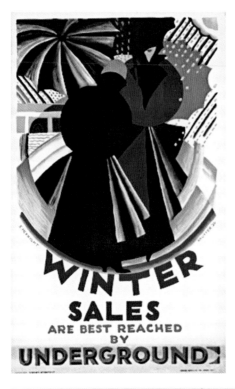

Winter Sales poster by Edward McKnight Kauffer, 1924. Kauffer was first commissioned by Frank Pick of London Underground in 1916, soon after he arrived in Britain. Over the next twenty-five years he became Pick's star poster artist and the most influential graphic designer in the country. (© TfL from the London Transport Museum collection)

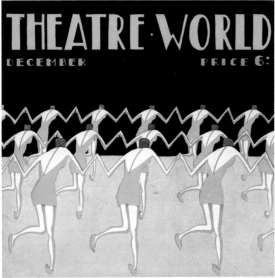

Cover of *Theatre World*, January 1926. The illustrator Bovey often created a jazzy art deco cover design for the monthly magazine at this time. (Getty Images)

The first breakthrough for modernism in British graphic design came with the Advertising Exhibition in 1927, a collective showcase for the industry. By this time the progressive influence of Continental modernism, particularly on lettering, had made art deco and modernism part of the mainstream. Further evolution followed in the 1930s as a new generation of designers adopted novel techniques such as airbrushing and photo montage in their commercial work to distinguish it from traditional advertising styles. Graphic design had come of age and the faintly patronising and dismissive term commercial art was gradually replaced by this new professional description.

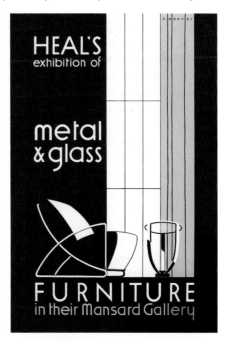

As the leading retailer of modern furniture, Heals had regular interior design exhibitions in their London store, advertised with appropriately modern posters. This show in 1933 includes their newly introduced range of chrome steel chairs. (Heals/V&A)

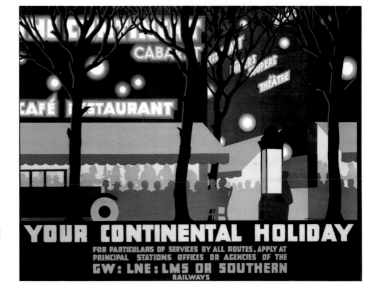

Poster promoting holidays on the Continent by P. Irwin Brown, 1932. This was produced on behalf of the four main-line railway companies, who all owned ships crossing the Channel and the Irish and North Seas. (Getty Images)

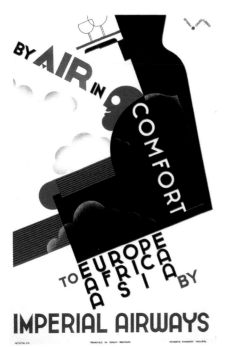

Left: An art deco Imperial Airways poster by Steph Cavallero, 1937, emphasises comfort and service rather than speed. It also shows nothing about the plane or the destination, a quirky new approach to advertising by the Stuart's agency. (British Airways Heritage Collection)

Below: 'By Bus to the Pictures Tonight', 1935. A London Transport poster by Tom Eckersley and Eric Lombers, two young designers who had recently left Salford School of Art and were experimenting with modernist graphic styles using montage and airbrushing. (© TfL from the London Transport Museum collection)

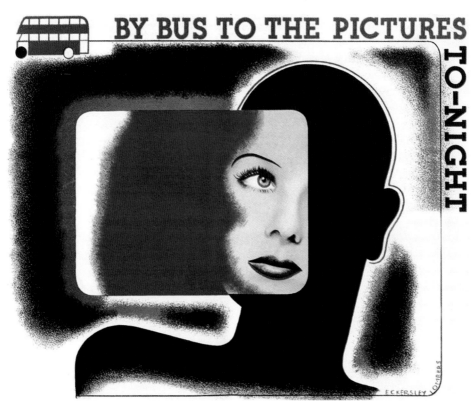

3
Domestic and Suburban

The domestic building industry had virtually collapsed during the First World War and the promise of 'homes fit for heroes' was a major commitment for Lloyd George's post-war government. For the first time every local authority in Britain had to start building low-rent council housing and there was also a big expansion in the private housing market, which has never been repeated. Before the war nearly everyone in Britain had rented their homes, but now private ownership was available to the middle classes as low-deposit mortgages were offered by building societies. There was soon a building boom in the 1920s, particularly in the south-east of the country around London, where new suburbs quickly colonised the city's outskirts in rural Middlesex and Surrey.

Nearly all the new housing was traditional in style, whether local authority or privately built, and was concentrated in low-rise estates where the houses were usually semi-detached, with gardens. As car ownership was still low, the new suburbs were usually built close to a local railway station or served by new bus routes to the station and shops. In some large regional cities such as Birmingham and Liverpool, housing followed new dual carriageways on the edge of town with tramways running down the centre section.

There were few experiments with modernist housing on the new suburban estates created in 1920s Britain, and it was not until the 1930s that the handful of early private commissions of art deco homes was extended to the open market on speculative estates.

Did you know?

Art deco versus Tudorbethan in Metroland
Amersham in Buckinghamshire has one of the first radically moderne private houses in the country, located very close to the last and furthest flung of the housing estates developed by the Metropolitan Railway near its country stations in the area north-west of London they christened Metroland. The contrast exemplifies the stylistic extremes of suburban housing in the inter-war years. High and Over was designed by Amyas Connell for Bernard Ashmole, the Professor of Classical Archaeology at University College London, in 1929. It has an unusual Y-shaped profile and a white concrete frame with a flat roof, the epitome of Continental moderne, facing out over the Misbourne valley. It is only a short walk from the railway station that had prompted the development of upper Amersham on the hill. Alongside the railway at the top is the Weller Estate, two new tree-lined streets of conventional detached and semi-detached properties built in the early 1930s by Metropolitan Railway Country Estates Ltd. These are even closer to the station, and no doubt many of the residents of these very different properties saw each other on their daily commute.

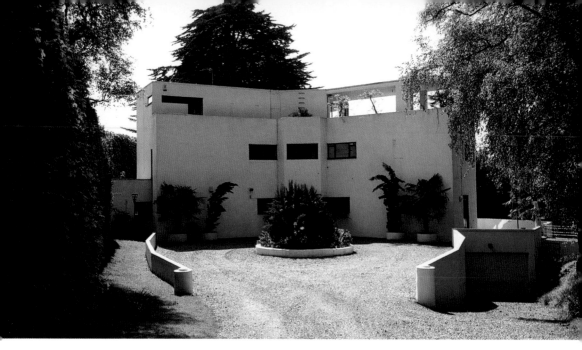

Above: High and Over, at Amersham, Buckinghamshire, was one of the first large privately commissioned moderne houses in Britain, designed in 1929.
Below left: Poster advertising the Weller Estate in Amersham, built just up the road from High and Over by Metropolitan Railway Country Estates, 1933. This was a typical Metroland development, entirely traditional in design, with Tudorbethan semi-detached houses. (© TfL from the London Transport Museum collection)

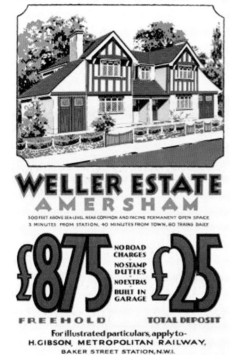

Art deco features in Metroland might go as far as details such as sunburst decoration on front doors, windows and gates, but white, flat-roofed properties were rare. An exception was the small group of architect-designed modernist properties built close to the new Metropolitan Railway branch terminus at Stanmore, now the northern end of the Jubilee line. The houses, each to a different moderne design, are a complete stylistic contrast to the hipped-roof Arts and Crafts station building, itself quite unlike the new Piccadilly line extension stations of the Underground a few miles away. London's new suburbs were providing more architectural variety than most critics gave them credit for, but it was a niche market.

Modernism was deemed more acceptable in the suburbs where it was applied to shopping parades rather than domestic properties, although these did often incorporate flats above and, from the 1930s, that essential suburban feature, a new cinema. By the 1930s a more austere red brick modernism was also being

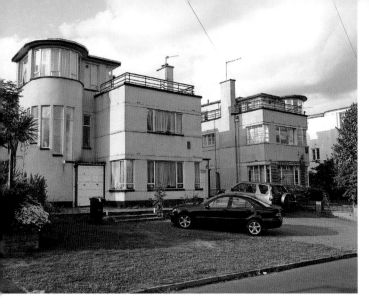

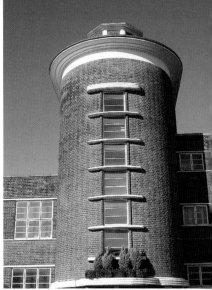

Above left: Architect-designed moderne housing in Stanmore, north London, two minutes' walk from the new Metropolitan branch terminus opened in 1932. This was an unusually avant garde suburban estate where each house was different.

Above right: The Lady Bankes School in Hillingdon, north-west London, built by Middlesex County Council in 1936/7. Municipal modernism at the heart of an extensive area of conventional suburban semis developed by speculative builders without architects.

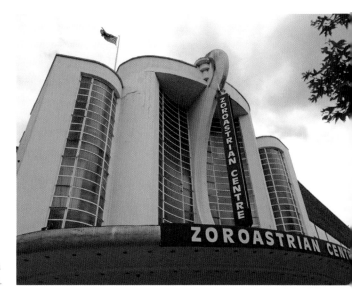

The most spectacular art deco cinema in London's Metroland was opened at Rayners Lane in 1936 as part of the new suburban shopping parade built around the Underground station. Closed as a cinema in 1986, it is now used as a church by the Zoroastrian Centre.

applied to the public infrastructure of the suburbs, particularly for schools, libraries, medical centres, and swimming pools. Middlesex County Council's architects were particularly fond of a stripped back modernist look for their new suburban civic buildings. There are a number of modernist state schools in north London surrounded by large traditional-style housing estates constructed by private developers at the same time. Nowhere in Britain did new suburban development follow the more consistent modernist style adopted for civic and private development alike in the Netherlands, for example.

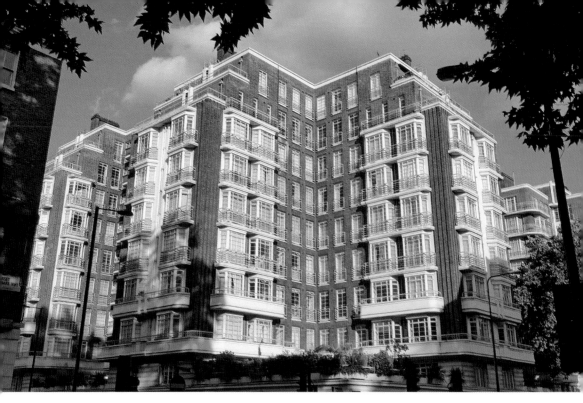

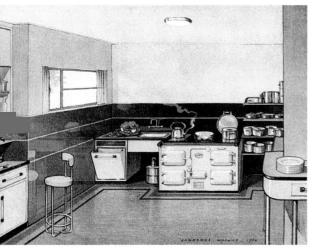

Above: Dorset House, Marylebone, a large art deco service block of ten stories, originally with its own petrol station and two underground floors for car parking. It was built by T. P. Bennett & Son in 1934–5 with Joseph Emberton as design consultant. **Left**: A stylish modern kitchen design illustrated by Lawrence Wright for an Aga advertisement in 1936. A fitted kitchen on this scale would have been an expensive luxury at the time. (Nick Wright)

The low rise 'cottage estate' layout in the Arts and Crafts style was followed by nearly all local authorities and private developers in the UK. Large apartment blocks for low-rent social housing, a system favoured in Berlin and Vienna in the late 1920s, did not become popular in Britain and only a few such estates were built in the 1930s, notably in Leeds and Liverpool. In London, there were smaller blocks of flats in a modernist style featuring rounded art deco balconies and steel frame 'suntrap' windows, but apartment living never became the norm, as it always had been in Paris and New York.

A complete art deco interior was never characteristic of new domestic properties built in the 1930s. They feature in period magazines about home decoration and museum

set-piece reconstructions of period interiors, but popular taste was generally more comfortable with conventional design than anything too 'modernistic'. The bathroom was often the only room in the house to be fully fitted out with modern sanitary equipment, where bath, basin, taps, tiles and mirrors could all be colour and style co-ordinated in a deco look. New kitchens, by contrast, were not yet fitted or even consistently designed for efficient use of small spaces. The latest gas cookers showed little input from industrial designers and new houses might have a small pantry off the kitchen for perishable food storage but certainly not a refrigerator. These would become the largest domestic products to be given a streamlined appearance by American designers, but there was not yet a consumer market for them in Britain.

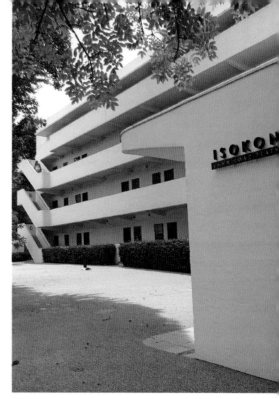

Above right: The Lawn Road flats in Hampstead, designed by Wells Coates and built by Isokon in 1934. Former Bauhaus teachers Walter Gropius and László Moholy-Nagy were among many European émigrés who lived here after escaping from Nazi Germany.
Below: Embassy Court, Brighton (far right), designed by Welles Coates in 1935, has been comprehensively renovated in recent years. It still stands out as a distinctive modernist landmark on the Regency promenade.

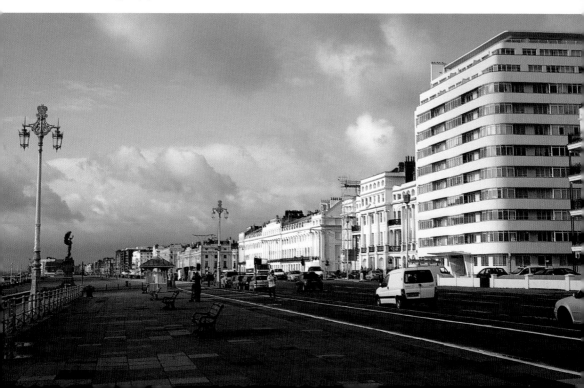

The complete modernist look inside and out clearly had strictly limited appeal to the homebuyers of the 1930s, and new art deco apartment blocks did not spring up everywhere. Some were effectively social experiments in a new type of communal living, such as the Lawn Road flats in Hampstead (1934), designed by Wells Coates and built by Isokon, but these were exceptional. On the South Coast prominent streamlined blocks like Coates' stylish Embassy Court on the seafront in Brighton (1935) and the even larger Marine Court at St Leonards on Sea (Dalgleish & Pullen, 1936–8), were powerful statements but this was not the domestic lifestyle most people aspired to.

On a more modest scale, flat-roofed domestic deco can be found as far apart as the fringes of Leven in Fife and Poole Harbour in Dorset, as well as the comfortable suburbs of Oxford and Cambridge, where the houses presumably appealed to more forward-thinking academics and university staff. One of the most ambitious projects was the Frinton Park Estate in Essex, begun in 1934. It was to have varying art deco properties designed by the architect Oliver Hill, but the project stalled with only a few houses complete. The all-modernist look of the estate was then compromised with conventional bungalows interspersed with deco to offer buyers a safer alternative. Today, Frinton's deco enclave has acquired a fashionably niche appeal and the white houses are being rapidly renovated.

A modest detached 1930s deco house with a rooftop view of the countryside from the sunroom. This is the last house on the edge of town in Leven, Fife.

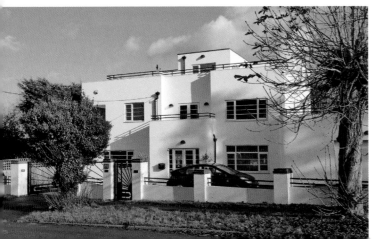

A large detached art deco property in Oxford. Most of the other houses on this small estate are not white and follow a more conventional design with a hipped roof.

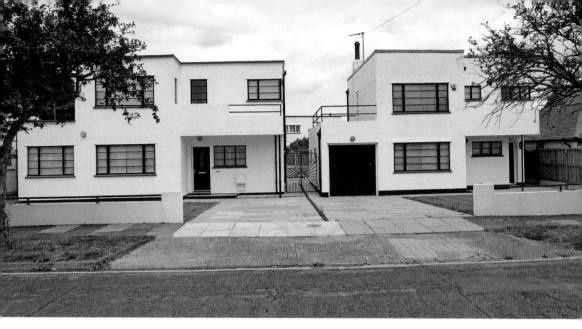

Refurbished art deco homes designed by Oliver Hill for the Frinton Park Estate in Essex, 1934. Sea views are five minutes' walk away.

Did you know?

If all-out modernism seemed too daring and extreme to appeal to most homebuyers in the 1930s, a modern design for new household products and decorative features became almost inevitable. Telephones and radios were both completely new forms of mass communication brought into a growing number of homes in the 1920s and '30s. Their design inevitably evolved from functional machine to home furniture, required to blend with the interior design. Early radio sets were made of wood and their cases derived from traditional furniture forms, but as manufacturers adopted synthetic resins and plastics, art deco designs proved particularly suitable and appealing for mass production and marketing. The General Post Office (GPO) was soon offering its latest moulded bakelite telephones for home use in a range of colours, though most consumers stuck to black.

Decorative domestic items such as mantel clocks, glass and ceramics also took on the various stylistic characteristics of art deco. British potteries were soon creating utilitarian and decorative wares in innovative new shapes and decorated with strong geometric patterns, stylised landscapes and animal figures. These were usually hand finished by 'paintresses' but were essentially mass-produced in factories, bringing art deco to a wide domestic market in the UK in the 1930s, where ten years earlier it had all been exclusive and expensive.

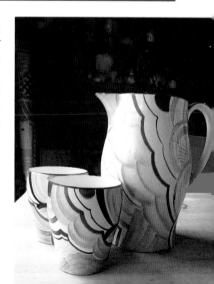

Art deco ceramics designed by Susie Cooper and made at Gray's Pottery, Staffordshire, c. 1928.

4
Leisure

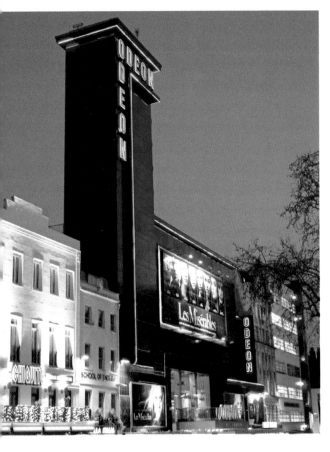

Art deco design came to exemplify the leisure environment of 1930s Britain, and especially the cinema. By the mid-1930s 'going to the pictures' had become by far the most popular commercial leisure activity in the country. A newspaper survey in 1938 concluded that 31 per cent of the population went to the cinema once a week and a further 13 per cent went twice, making up some 18 million visits a week.

Elaborate interior decoration was an established feature of theatres and music halls before the First World War, and cinemas inherited this tradition as the silver screen began to take over in the 1920s and was boosted by the arrival of the 'talkies' at the end of the decade. Large 'atmospheric' cinemas imitating American developments appeared in London in the late 1920s, soon adopting the stylised art deco already popular in new German cinemas.

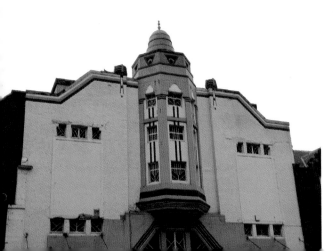

Above left: The dramatic black Odeon Leicester Square was designed by Harry Weedon and Andrew Mather. It took just seven months to construct, opening with the *Prisoner of Zenda* in October 1937. Today it is still the flagship of the Odeon chain, completely modernised but with a fully restored art deco auditorium.
Left: The peeling art deco façade of the former Rialto cinema in Ayr, Scotland, first opened in 1931 but now closed and facing an uncertain future.

Did you know?

Three rival cinema groups, ABC, Gaumont and Odeon, were responsible for the dramatic growth of new cinemas across the country in the 1930s. It was the Odeon chain in particular that established an instantly recognisable house style throughout Britain, and became associated with a distinctive streamlined art deco look. In nearly every town centre and suburb, a new cinema was often the largest building, and constructed incredibly fast with the minimum oversight from local planning authorities. These were modern facilities available to all which every town wanted and there were few objections to their arrival. The newspaper survey in 1938 estimated that only 4 per cent of British twelve-year-olds never visited the cinema and that Walt Disney's newly released animated feature film *Snow White and the Seven Dwarfs* had been seen by one third of the UK population!

More than 300 new cinemas were built between 1930 and 1940, covering every town in the country, and by this time nearly all of them were designed in some version of art deco style. Even if they did not notice the style anywhere else, the new movie palaces were the places where almost everybody soon encountered art deco on a regular basis. Other leisure buildings adopted the fashionable deco style, with many luxury hotels and theatres

The former Odeon Leicester, built to the designs of Harry Weedon and Robert Bullivant in 1937–8. Closed as a cinema sixty years later, it is now an entertainment centre run by Athena.

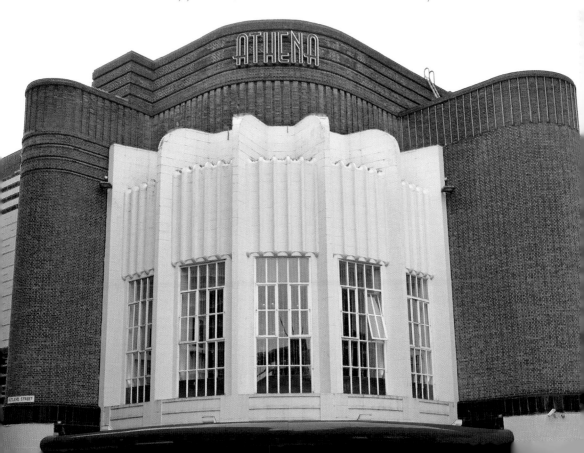

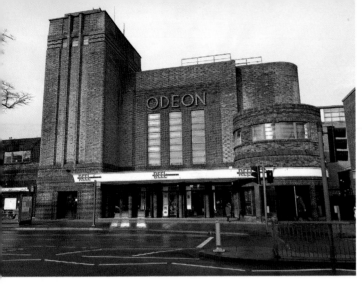

The Odeon York, also by Weedon and Bullivant, 1937–8. The architects' exuberant house style had to be toned down in this historic city, where cinema construction inside the city walls was banned. It is still a working cinema, now run by the Vue chain.

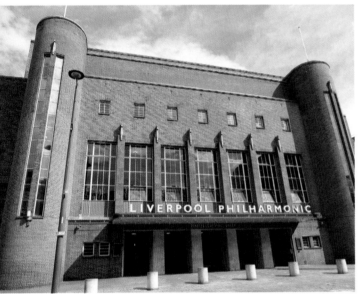

The modernist Philharmonic Hall in Liverpool (Herbert J. Rowse, 1936–9) replaced the Victorian concert hall here, which burned down in 1933.

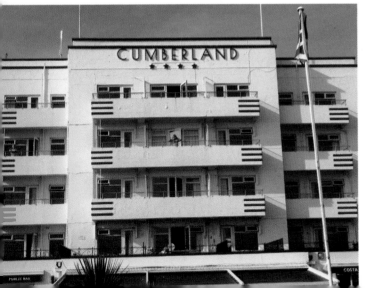

The art deco Cumberland Hotel, opened on the cliff top overlooking the sea at Bournemouth in 1937.

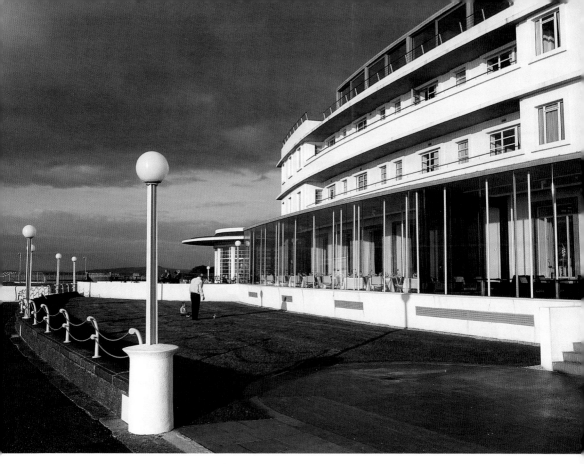

Above: The LMS railway company replaced their Victorian seaside hotel at Morecambe with this startlingly modern art deco building designed by Oliver Hill in 1933. The new building retained the old name, the Midland Hotel.

Below right: The main lounge of the Midland Hotel, Morecambe, as restored by Urban Splash in 2008, with copies of Marion Dorn's original ripple-effect art deco circular rugs. Original interior decorative features by Eric Gill have also been renovated.

being rebuilt or modernised with an 'Odeon' look to their décor. London's big hotels were not exactly accessible to all, but an art deco makeover that seemed to replicate the interior of the local picture palace was clearly considered good for business.

The streamlined style became particularly popular at seaside resorts, where new hotels, lidos and swimming pools sought to offer a Mediterranean look with white painted concrete exteriors, rounded corners and balconies and flat roofs. The Midland Hotel at Morecambe and the Burgh Island Hotel in Devon are two striking examples of bright white deco given prominent coastal locations. Joseph Emberton, who was trained as an engineer, not an architect, contributed two of the most dramatic modernist buildings by the sea, the Royal Corinthian

Yacht Club at Burnham-on-Crouch in Essex (1932) and the Casino at Blackpool Pleasure Beach (1939). The British weather often spoiled the south of France illusion, but the art deco look must have helped encourage the 1930s enthusiasms for rambling, healthy exercise, outdoor swimming and sunbathing.

Perhaps the most successful and radical example of seaside modernism in Britain at this time is the extraordinary De La Warr Pavilion at Bexhill-on-Sea, Sussex. The new building was the result of an architectural competition initiated by the 9th Earl De La Warr, a committed socialist and Mayor of Bexhill, who wanted a distinctly modern public leisure building for his town. The Royal Institute of British Architects (RIBA) organised the competition in 1934. The rules specified that the design had to include an entertainment hall for 1,500 people, a large

The Royal Corinthian Yacht Club at Burnham-on-Crouch, Essex, designed by Joseph Emberton in 1932.

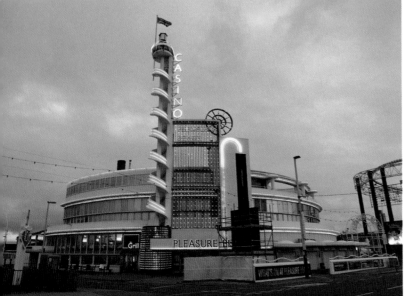

The Casino at Blackpool Pleasure Beach, also by Emberton, was completed in 1939. This striking modernist design replaced an elaborate Edwardian white wedding cake building.

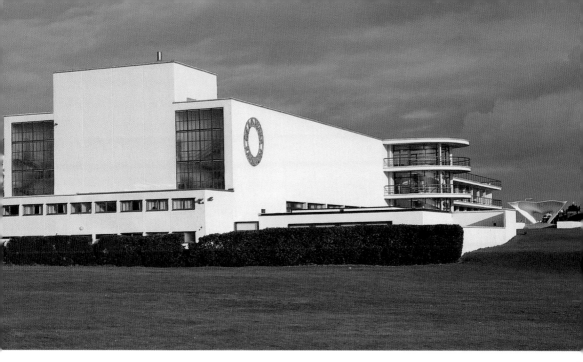

Above: The sleek De La Warr Pavilion at Bexhill-on-Sea, opened in 1937, is the finest example of Continental modernism in England, now carefully renovated as an arts centre.
Below right: The elegant spiral staircase of the De La Warr with its Bauhaus-style globe lamp.

restaurant and reading room and an outside swimming pool.

The architects selected from 230 entrants were leading figures in the modern movement, Eric Mendelsohn and Serge Chermayeff, whose innovative design featured the first use in Britain of a welded steel frame, pioneered by structural engineer Felix Samuely. This allowed for extensive use of large glass windows, curved contours and very rapid construction in less than a year. The De La Warr was opened on 12 December 1935 by the Duke and Duchess of York, soon to become King George VI and Queen Elizabeth. Today the De La Warr is a Grade I listed building, sensitively restored in 2005 as an arts centre, and widely regarded as the best example of streamlined moderne in the country.

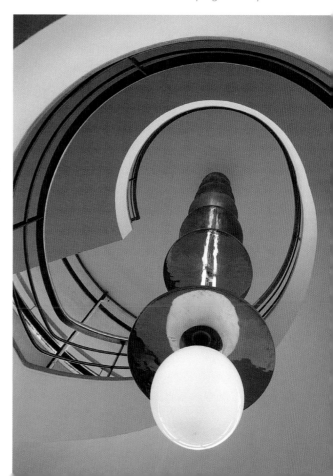

5
Civic Buildings, Education and Remembrance

Art deco and modernism began to shape buildings and monuments with a far more serious purpose than leisure and relaxation. In fact it could be argued that the Cenotaph in Whitehall, designed by Sir Edwin Lutyens in 1919 as a national shrine to the war dead, was stylistically the first art deco structure in the country. This modest memorial began as a temporary monument of wood and plaster erected for the Peace Day celebrations of July 1919, and was rebuilt in Portland stone as a permanent memorial to be unveiled on Armistice Day 1920. The Cenotaph did not set a precise model for the war memorials that followed across the country, but its simplified style was a complete change in tone from monuments that glorified combat or victory.

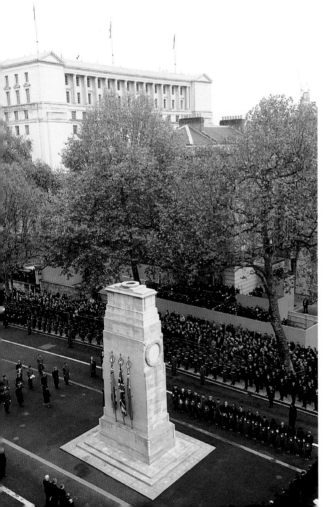

New public buildings were nearly always built to stripped-down modernist designs at this time. Town halls and civic centres, of which there were a surprisingly large number constructed in the 1930s, were more likely to emulate the characteristic north European modern brick building styles of the Netherlands, Denmark and Sweden. Many of them feature elaborate deco metal or stonework in their entrance areas to offset their substantial but rather plain and undecorated exteriors. None of them go so far as to feature art deco streamlining, keeping a more restrained and serious appearance for local government and religion that could never

In 1920 the Whitehall Cenotaph set a permanent standard for the war memorials that followed up and down the country, many of them adopting the simplified and stylised features of art deco design. (Ministry of Defence)

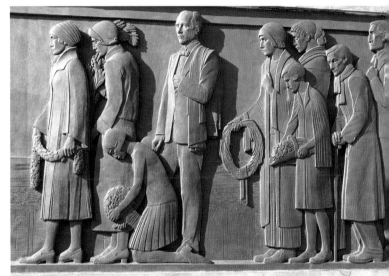

Right: Detail of the bronze relief on the Liverpool Cenotaph by Herbert Tyson Smith, 1930.

Below: Hornsey Town Hall, London (Reginald Uren, 1933–5), was the first major UK building to be constructed in a modernist style influenced by Dutch and Swedish design.

TO · ALL · THE · PEOPLE

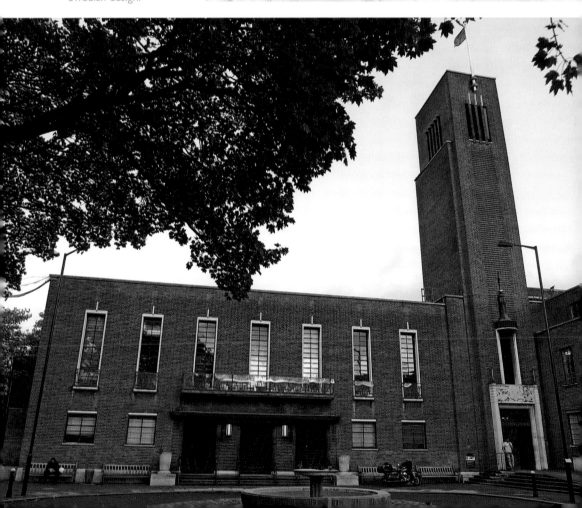

Above: The art deco Newport Civic Centre in south Wales (Thomas Cecil Hewitt 1937–40) was finished, apart from its great clock tower, in the early months of the war. The tower was not completed until 1963/4. (Git Absarnt/Wikipedia)
Left: The Guildhall at Kingston-upon-Thames (Maurice Webb, 1935) is primarily neo-Georgian in style but has extensive art deco metalwork and Portland stone decoration round the main entrance.

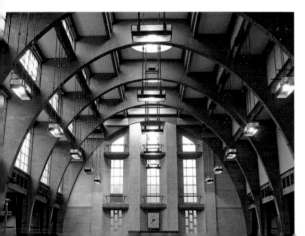

Lawrence Hall, London (Easton & Robertson, 1925–8), was one of the first large UK buildings to use an art deco-styled concrete frame. It was built for the Royal Horticultural Society as an exhibition hall and is now leased to Westminster School as a sports centre.

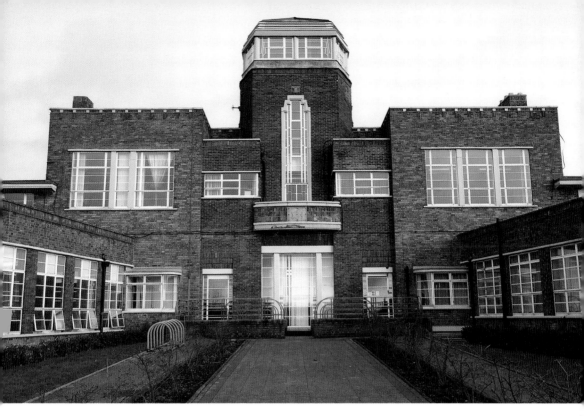

Above: The John Marley Centre in Scotswood was originally built as a secondary school in 1936, and is now a campus of Newcastle College.
Below right: The great art deco library tower of Senate House, University of London (Charles Holden 1932–7), was controversial at the time because of its overpowering dominance in Bloomsbury.

be mistaken for a palace of leisure or entertainment. This modernism was a long way from Odeon style.

Some of the grandest new education buildings were designed for universities. Charles Holden's Senate House complex for the University of London, with its great central library tower, dominates Bloomsbury and even overshadows the British Museum. It resembles an overblown version of his Underground headquarters but it is somehow out of scale, with less attention to detail and the omission of decorative sculptures on the façade, where the niches were left bare. The building was taken over by the Ministry of Information during the war and is said to have inspired George Orwell's sinister Ministry of Truth in his dystopian novel *1984*.

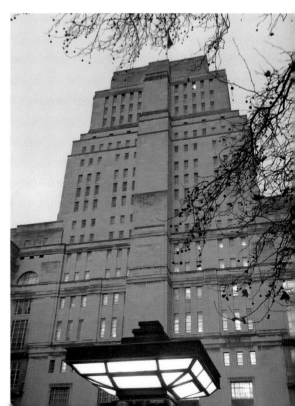

6
Industrial and Commercial

Art deco and modernism provided a complete change in the work environment, particularly for modern factories and offices. Where traditional heavy industries were still located in grim and dark nineteenth-century factories with steam-driven machinery like textile mills, new light industries could be established in a cleaner, brighter environment with electric power, dust extractors and production lines. The work itself might still be repetitive and tedious but the circumstances were healthier and much improved. Above all, it gave big commercial companies a new, progressive image.

The construction of new arterial roads in west and north London encouraged new factory development along them. Light industries, and especially branches of American manufacturers, set up shop on the Great West Road, Western Avenue and North Circular Road. The 'golden mile' of the Great West Road in Brentford had a particular concentration of new factories created in the 1930s with decorated modernist street façades that could have been transported from California, and many of them were run by British subsidiaries of big American companies. Similar modern factories and commercial premises in deco style appeared in regional cities such as Glasgow, Liverpool and Nottingham.

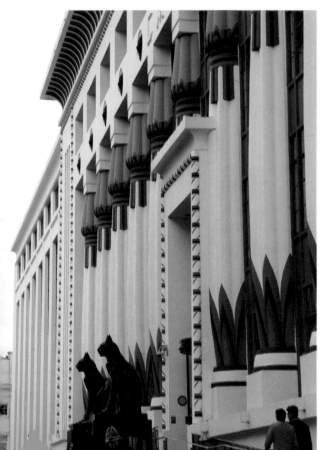

The Arcadia building in Camden, north London, built by Carreras as an ultra-modern cigarette factory in 1926–8. Its Egyptian-style art deco frontage was originally faced in Atlas White cement, coloured to look like sand.

Many of these inter-war industrial buildings survive, though none are owned by the original companies that set them up or are used to manufacture their former products. Gillette razor blades, Coty cosmetics, Pyrene fire extinguishers and Trico windscreen wipers have all long gone, but the art deco buildings have new owners and new uses, mostly as offices. Only the strikingly modern Boots factory at Beeston, Nottingham, is still in everyday

The former Coty cosmetics factory on the Great West Road in Brentford, west London (Wallis Gilbert, 1932), now the Syon Clinic.

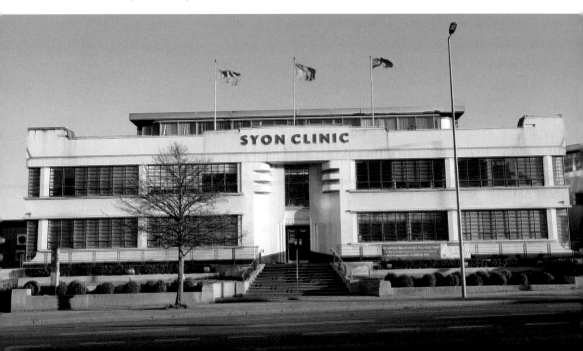

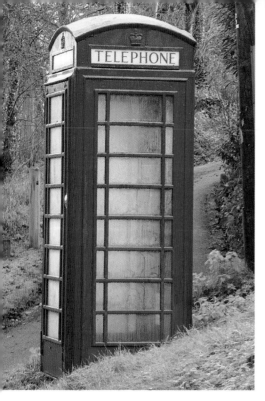

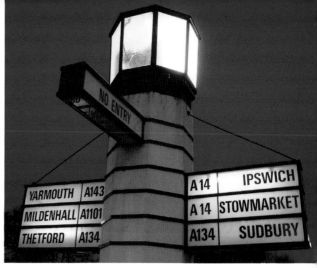

use making medical and cosmetic products. The best-known art deco landmark in London, the former Hoover premises on the Western Avenue, closed down in the 1980s. The main production area at the back of the building was adapted to create a Tesco superstore, but the rest remained empty for years. Happily the main Grade II* listed administration building has finally been converted into apartments and its future looks secure.

Variations on an art deco or modernist theme were adopted by many architects and designers in the 1930s to dress prominent industrial buildings large and small. Sir Giles Gilbert Scott achieved this beautifully on a huge scale with Battersea Power Station (front cover) and, at the other end of the spectrum, with his classic K6 telephone kiosk (1935). Despite its bulk, Scott's power station became a familiar landmark to Londoners and was listed for preservation after it closed in the 1980s. Restoration schemes have come and gone, leaving Battersea as a decaying shell for over forty years, but conversion to apartments is now under way. Scott's red telephone boxes multiplied all over the country and became the perfect piece of practical street furniture, suitable in any urban or rural environments. When they became effectively redundant in the age of the mobile phone, many were preserved as decorative features without a phone.

New office buildings in London designed in the early 1920s were usually classical and pompous, looking back to the grand Edwardian years rather than to a new style for the future. But by the end of the decade the national newspaper barons were competing to create new physical statements of their power on Fleet Street. New offices for the *Daily Telegraph*, fronted by an enormous art deco clock, opened in 1928, trumped four years later by the even more modern offices of the *Daily Express* almost next door (1930–2).

The shiny black vitrolite and glass-fronted *Express* building by architects Ellis & Clark and engineer Owen Williams, with its lavish interior decor featuring art deco panels representing Britain and the Empire, clearly signposted the ambition of Lord Beaverbrook, the paper's

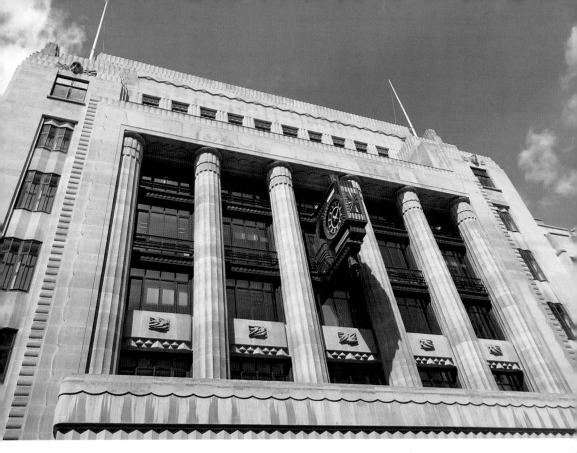

Above: The art deco clock on Peterborough Court, the former *Daily Telegraph* offices in Fleet Street, London, designed by Thomas Tait in 1927. It is now owned by Goldman Sachs International.
Right: Detail of the black vitrolite panels of the *Daily Express* offices, opened just along Fleet Street from the *Daily Telegraph* in 1932. The building has a radically different streamlined style which owes as much to engineering as architecture.

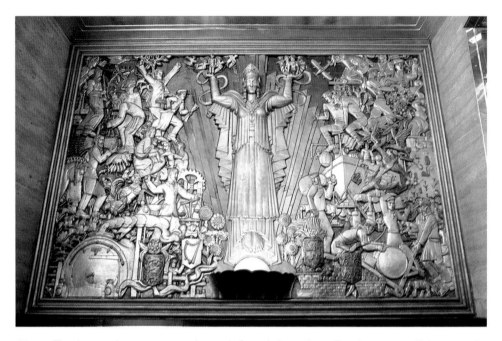

Above: Two large and impressive art deco relief panels by sculptor Eric Aumonier still dominate the entrance lobby of the former *Daily Express* building in Fleet Street. This is *Britain*, the other is *Empire*. (Steve Cadman/Creative Commons)

Below left: Ibex House, the only large streamline modern office building in the City of London, opened in 1937.

Canadian owner. The *Express* claimed to have the highest and fastest growing newspaper circulation in the world at this time. Williams went on to engineer similar buildings for the Glasgow and Manchester offices of the *Express*, both incorporating a printing plant which was visible at night through the large glass windows. The aesthetic change between the *Telegraph* and *Express* buildings also demonstrates the stylistic divergence of art deco in just a few years from gaudy decoration to a sleek form of industrial design that owed as much to engineers as architects.

In the City of London the banks and other financial institutions nearly all stuck to traditional styles, but one enormous modernist office building, Ibex House, took up the modernist challenge in 1937 and became the only major art deco structure

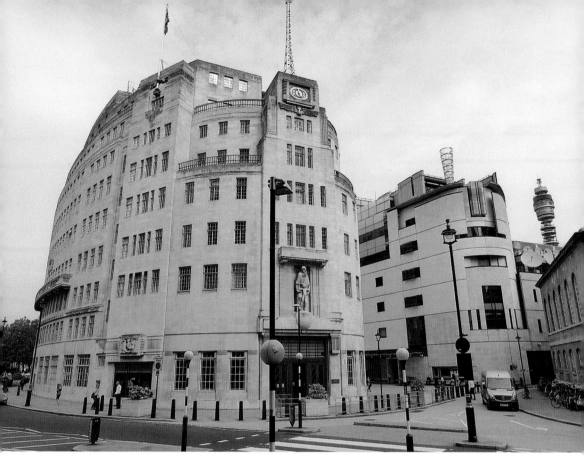

Above: Broadcasting House, the BBC headquarters in Portland Place, London, designed by George Val Myer and built between 1928 and 1932. Eric Gill's sculpture of Prospero and Ariel is over the entrance doors. The extension building added in the twenty-first century is on the right.
Below right: Main staircase of the Royal Institute of British Architects (RIBA) building, also in Portland Place, designed by George Grey Wornum in 1932–4.

in the Square Mile. Just across the river a strikingly modern and distinctive office building overlooking the Thames was created by H. S. Goodhart Rendel for the Hay's Wharf Company in 1928–32, featuring art deco lettering and relief sculptures by Frank Dobson.

This was a particularly creative period for modernist office developments. The BBC's Broadcasting House rose up like a great white liner in Portland Place in 1931–2 and just down the road a new building for the RIBA followed. On the Thames Embankment there was soon a large new art deco headquarters for the Shell-Mex Company, and also the adjacent New Adelphi office block. All these bulky new edifices used white Portland stone covering an invisible structural steel frame,

the standard construction technique by this time, following American skyscraper technology. They also often featured modernist sculptures on the street facades and etched glass on staircases and doors.

Department stores were equally keen to modernise their image in art deco style. In west London, Barkers and Derry & Toms, two adjacent stores on Kensington High Street, both embarked on reconstruction once under single ownership. Derry & Toms was given Europe's largest roof garden as an added attraction, while Barkers had the more dramatic new street façade, too ambitious to be finished before the war. Both were refitted internally as art deco palaces. Stores in regional cities were only a little smaller, notably the new or rebuilt art deco branches of Lewis's which opened in Leicester, Leeds and Liverpool. Even the conservative and reliable Co-op opened big new extended stores with art deco façades in Doncaster, Newcastle and other cities.

Modern glass shopfronts made extensive use of brighter lighting and curved or angled shop windows, including neon signs and lettering. Joseph Emberton, who had worked on exhibition designs at Olympia and Earl's Court, moved on to large shopfronts like Simpson's menswear in Piccadilly (1936) and the new HMV record store in Oxford Street, which even included a neon version of Nipper, the famous HMV dog, on the façade. On a smaller scale but equally dramatic at night were many clothes and shoe shops. A brash, streamlined art

Below left: The redevelopment of Barkers department store in Kensington was planned in deco style in the 1930s, but was not completed until 1958 because of wartime delays to the project.
Below right: The Co-op department store in central Newcastle was rebuilt with a large art deco extension in 1932, designed by in-house architect L. G. Ekins. It has recently been converted into a Premier Inn hotel.

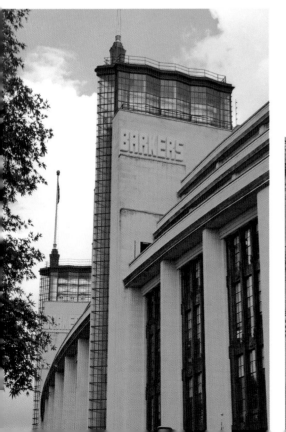
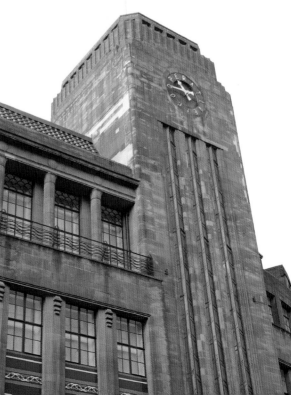

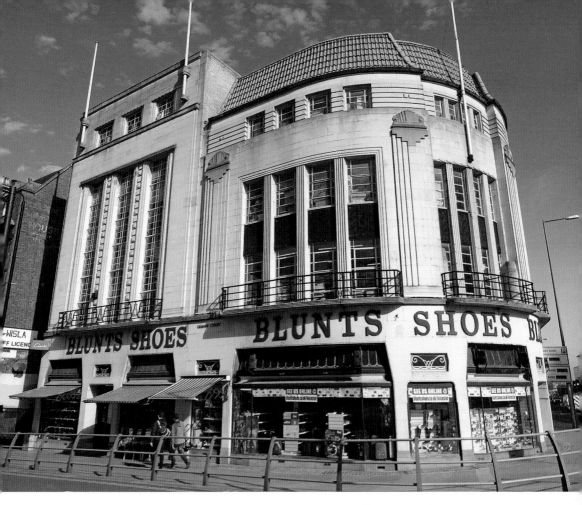

Blunts shoe store in Leicester has one of the most elaborate 1930s art deco façades in the country.

deco look was also popular with new cafés and milk bars which gave them a bright, attractive look at night and a touch of New York glamour.

The most consistent corporate style was introduced by Burton's, the men's outfitter, whose in-house architects designed very similar stores on nearly every high street, starting in West Yorkshire and virtually replicated across the country. They all have a distinctive white-tiled faience façade, often located at a road junction in the centre of town, with a billiard hall on the first floor, combining a retail outlet with a social function that was driven by philanthropy as well as profit.

Even Woolworth's, whose plain modernist shop façades with distinctive red lettering spread rapidly across the country in the 1930s, decided to combine art deco and leisure retailing in their flagship store. Perhaps surprisingly, this was not in the Capital, but opened on the promenade at Blackpool in 1938, right next to the famous Tower. Unlike any of Woolworth's other stores, it was on four floors, two of them taken up with a vast self-service cafeteria featuring modernist styling in chrome and vitrolite. The giant building was topped off with a prominent clock tower of its own in art deco style. It survives today as a pub and discount store long after Woolworth's own demise as a company.

Above: Burton's distinctive art deco shopfronts are still instantly recognisable in any town, though most of them have new owners. This is the Durham store, which would once have had a billiard hall on the first floor.

Left: The former flagship Woolworth's store in Blackpool opened in 1938 next to the Tower. It occupied four floors, two of them housing a large American-style self-service cafeteria.

7
Transport and Travel

Art deco design often represents an attempt to come to terms with the new inventions and technologies of the early twentieth century. Surprisingly enough, this proved to be a slow and difficult process both for artists and designers. Some art movements like the Futurists were keen to demonstrate their enthusiasm for speed and technology but found it difficult to express this effectively in their art. Equally, the engineers and mechanics were much more interested in refining their machines to improve their performance than developing their appearance. Despite the rapid progress in aviation technology during the First World War and the production line methods developed for assembling cars, design developments remained slow in the 1920s. In Britain modernism was only physically expressed in transport design from the early 1930s, when the sleek look of streamlining was selectively adopted from the USA.

Railways

Britain's railways had been put under government control during the First World War. When the conflict was over it was decided to 'group' most of the 120 individual companies into just four large private operators. The 'Big Four' railways were the London & North Eastern (LNER), the London Midland & Scottish (LMS), Great Western (GWR) and Southern (SR). London's local passenger railways, the Metropolitan and the Underground, were left out of the 1923 grouping.

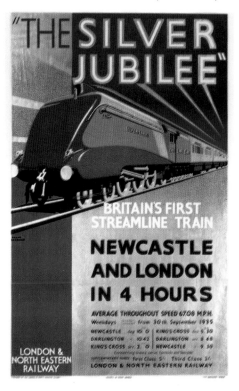

At a time when their profits were falling for the first time, none of the companies were keen to spend money on modernisation or new technology. Only the Southern promoted a major suburban electrification scheme and only the Underground planned, with government assistance, major new extensions. Across most of the country, trains were still steam-hauled, the design of carriages did not change significantly and the Victorian infrastructure, much of it in need of updating, remained essentially unaltered.

An LNER poster by Frank Newbould advertising the Silver Jubilee, Britain's first streamlined train, introduced between London and Newcastle in 1935. (Getty Images)

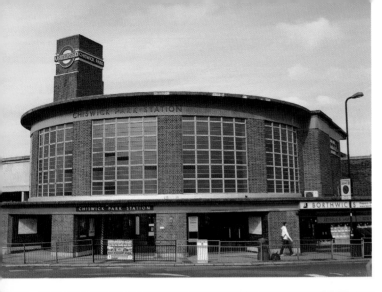

Chiswick Park, one of the new London Underground stations designed by Holden in 1931/2 after he had returned from a study tour of modern north European architecture with Frank Pick.

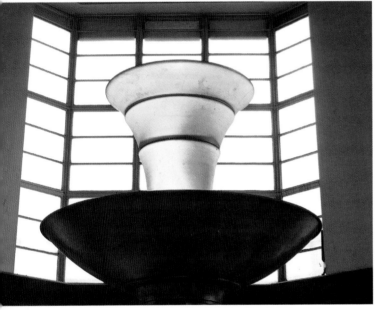

Art deco uplighter at Bounds Green Underground station on the Piccadilly line extension, opened in 1932.

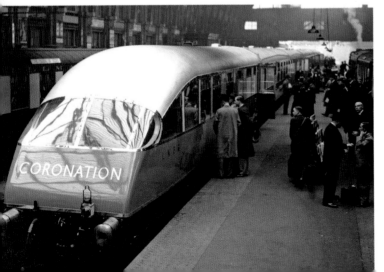

The 'beaver tail' observation car, with curved perspex windows, on the LNER's streamlined Coronation service introduced in 1937. These trains offered the fastest service yet between King's Cross and Edinburgh, completing the journey non-stop in just six hours.

Did you know?

The London Underground group, which also ran buses and trams in the capital, set a unique and progressive design standard for a public transport organisation, largely because of Frank Pick's insistence on 'fitness for purpose' throughout the company. Pick took a strong personal interest in design for all areas, from publicity and corporate identity to vehicles, engineering and architecture. He sent his senior engineers on visits to Europe and North America and even went with Charles Holden on an architectural study tour of cities in Germany, the Netherlands and Scandinavia when planning the Piccadilly line extensions in 1930. The result was the strongest and most integrated corporate identity in the country, subtly including design features they liked from German cinemas, a Dutch civic centre and a Swedish library. Holden mixed Scandi-modern with art deco and the Arts and Crafts tradition to stunningly modern effect which has stood the test of time better than any other 1930s architecture in Britain. London Transport (as it became in 1933) maintained its distinctive modernist feel in the design of new buses and trains, which were the best in the world at this time.

The main-line railway companies followed the Underground's design lead in some areas from the late 1920s. The LNER adopted Eric Gill's new Gill Sans lettering (itself derived from Edward Johnston's Underground typeface) for all its signage, commissioned the best poster designers (though not on the scale of the Underground) and made hesitant moves to rebuild suburban stations in a modernist style. Its real coup was the introduction of Britain's first streamlined train in 1935, the Silver Jubilee running up the East Coast Main Line non-stop from King's Cross to Newcastle.

The Southern Railway broke away completely from its conservative station designs with white art deco and concrete for new buildings at Surbiton, Southampton and elsewhere. It also publicised the 'sunny south coast' that it served with dramatic art deco posters, particularly when promoting the extended main line electric services to Brighton (1933) and Portsmouth (1938). But the Southern's new suburban electric trains remained very traditional, with compartments and slam doors, which looked decidedly old-fashioned compared to London Transport's latest semi-streamlined Tube trains with their air-operated sliding doors.

The LMS, Britain's largest railway company, began to invest in research and development in the 1930s but was always beaten in the publicity stakes by its main rival, the LNER. The LMS introduced its own streamlined steam expresses on the west coast route to Glasgow, but could never match the LNER for speed. It was also slow to deliver its much publicised plan to rebuild Euston in modern art deco style. The new booking hall and hotel in Leeds completed in 1938 give an indication of Euston's planned appearance, but the new London terminus never materialised.

Finally the Great Western, always a proudly conservative and traditional line, refused to engage in the streamlining of its steam locomotives. Art deco styling barely touched its express trains but it was applied to some experimental diesel railcars constructed for the GWR by AEC, the builders of London's buses. There was also some modernist station reconstruction carried out to celebrate the railway's centenary in 1935. An art deco office block was added at Paddington and the interior of the Victorian station hotel next door was completely refurbished in deco style. Other stations that were rebuilt in modernist style such as Cardiff and Leamington Spa have recently had their 1930s period features renovated or reinstated, including replica art deco lighting.

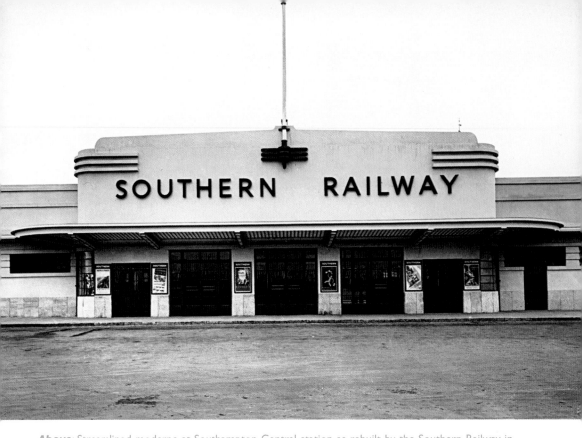

Above: Streamlined moderne at Southampton Central station as rebuilt by the Southern Railway in 1936. Not much of this survives today.
Below: A GWR streamlined diesel railcar built by AEC, the builders of London's buses, in 1934. It is now on display at the National Railway Museum, York. (GB114/Creative Commons)

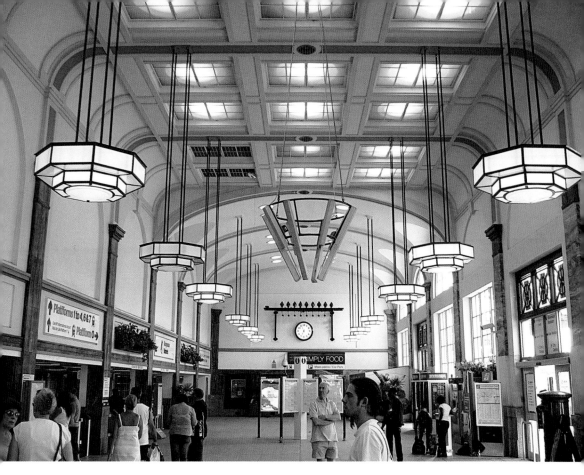

Cardiff station, reconstructed by the GWR in the 1930s, has recently been refurbished with replica art deco lighting installed.

Road Transport

The 1920s saw the first significant rise in motorised transport on Britain's roads. In towns, delivery vans and lorries replaced horse-drawn transport and petrol-driven buses started to replace electric trams, which were beginning to be seen as more flexible and cheaper to operate for public transport on the streets. Private cars became cheaper to buy but motoring was still far out of reach for most of the population. In 1920 there were 187,200 car licences in Great Britain, rising to just over two million by 1939.

British vehicle design in the inter-war years failed to keep pace with the technology that drove it, and until well into the thirties the refined, streamlined style of art deco was applied to many static buildings long before it was adopted for mobile car design. Surprisingly enough, it was the latest trams, a form of transport rapidly going out of fashion in the 1930s, that featured the most advanced streamlining on the roads. Those towns that hung on to their trams and designed their own new vehicles, notably Glasgow, Liverpool and Blackpool, offered the best modern corporation transport with stylish and comfortable vehicles that outshone and outlasted the latest buses. Cars, on the other hand, still looked decidedly primitive and the smooth bodywork with integrated mudguards and headlamps that was developed in the USA in the 1930s was absent in Britain. Chrysler's innovative Airflow was sold as a scaled down luxury children's pedalcar by Tri-ang toys but the full-size streamlined vehicle was a rarity on the roads.

Above: A Liverpool 'green goddess' streamlined tram, built in 1936 and later transferred to Glasgow. It has now been restored to working order in its original colours at the National Tramway Museum, Crich, Derbyshire.

Left: The Official Racecard at a Brooklands Automobile Racing Club event on Easter Monday, 1930. Graphic designers were trying hard to give an impression of speed in their designs. (Brooklands Museum)

Even in motor racing, effective streamlining was confined to a handful of individual designs like Malcolm Campbell's famous *Bluebird*. The impression of speed that an art deco design often conveyed was more effective on the poster illustrations and racecards for Brooklands than it was on the fast cars of Britain's most famous racing circuit.

Despite the enthusiasm of modernists everywhere for the motor car, the infrastructure needed to service and accommodate it generally lacked architectural and design quality. Few of the early petrol stations, garages and multi-storey

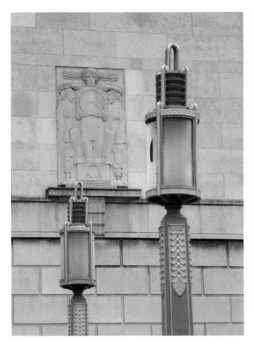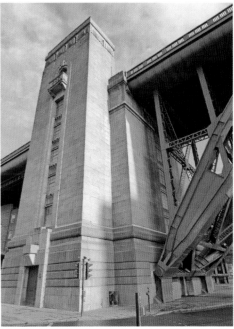

Above left: Art deco decoration on the lamps and ventilation tower of the Mersey Tunnel, Liverpool, opened in 1934.
Above right: One of the great support towers of the Tyne Bridge in Newcastle, opened in 1928.

car parks designed from the late 1920s onwards, some of which still survive today, can be considered elegant, though they often tried hard to be efficient and practical. Stylish art deco could be applied virtually anywhere and was used to great effect on the toll booths, lighting pylons and monumental ventilation towers of the Mersey Tunnel in 1934. It was also used on a grand scale in the design of the support towers for the new Tyne Bridge in Newcastle, opened by King George V in 1928.

Aviation

All aircraft were still quite primitive and unsophisticated when civil aviation began in the early 1920s. For prospective travellers even a trip across the Channel by air looked pricey and more than a little risky. When the grandly named Imperial Airways was launched as the national carrier in 1924, it did not transport many people very far and its commercial prospects, even with a government subsidy, looked poor. Imperial's home base at Croydon Aerodrome, just south of London, began operations with nothing more than a raggedy collection of sheds, hangars and just six aircraft.

There was no precedent for a passenger terminal building anywhere in the world and when Croydon's integral administration facility and air traffic control tower opened in 1928 it was a major innovation. Designed, constructed and operated by the Air Ministry, its bleak and strictly functional layout made few concessions to comfort or appearance. It was left to Imperial's poster designers to give Croydon and its planes the touch of glamour that they needed.

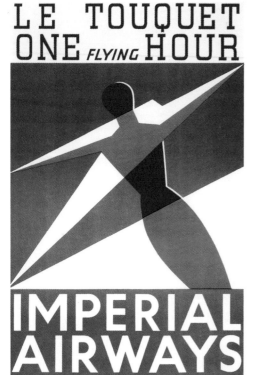

LE TOUQUET
ONE *FLYING* **HOUR**

IMPERIAL
AIRWAYS
THE MOST COMFORTABLE WAY

Poster for Imperial Airways by Theyre Lee-Elliot incorporating the famous 'speedbird' logo he designed for the company in 1932, which remained in use by Imperial and its successor BOAC for over fifty years. (British Airways Heritage Collection)

Even in the mid-1930s, Croydon attracted more day trippers than passengers and flying was still treated as a spectator sport rather than a serious means of transport. The British government's plans to make Imperial Airways a self-sustaining business still looked hopeless, but modernism was catching up rapidly with aviation in the design of both airports and aircraft. The original 1930s terminal buildings still surviving today at Gatwick, Birmingham and Speke (Liverpool) were all far more advanced designs than Croydon, though all now have other uses. Shoreham Airport on the South Coast is the best white art deco survivor from the period that is still operational.

Meanwhile, new British aircraft were acquiring a much sleeker, streamlined appearance in the 1930s that matched the publicity image created by Imperial's new advertising agency. Stuart's used modern artists like John Piper and Ben Nicholson in their promotion, and commissioned the slick Speedbird logo from designer Theyre Lee-Elliott, which soon appeared on every new plane.

In 1934 Short Brothers of Rochester were commissioned to design and build twenty-eight streamlined flying boats for long-distance routes, where they were intended to replace Imperial's reliable but lumbering giant biplanes. While land planes continued to use Croydon, Southampton became the operational centre for Imperial's flying boats, first launched in 1937. Imperial's posters and publicity made the most of these impressive developments, in which British aviation was proving as advanced as the United States and covering greater distances across the globe than any other European nation.

Imperial was soon building a grand new art deco headquarters building and flight terminal next to Victoria station in central London. Special trains would run straight from a station platform alongside to Southampton, where passengers could transfer on to flying boats just as they did when boarding liners. The new transatlantic flying boat service was about to take off when war broke out in 1939, and all Imperial's services were immediately closed down. Civil aviation would not emerge again for six years, until the post-war expansion of a new nationalised body that replaced Imperial, the British Overseas Airways Corporation (BOAC). Imperial's impressive art deco headquarters is now occupied by the National Audit Office.

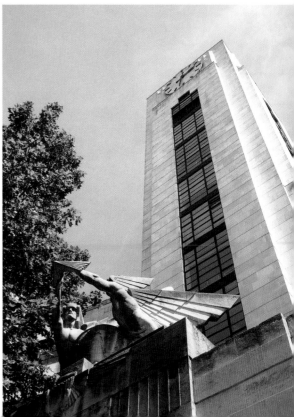

Above: A DH.34 Rapide, the most successful semi-streamlined small passenger aircraft developed in Britain in the 1930s. This example is still in regular use on short sightseeing flights from the Imperial War Museum Duxford, near Cambridge.

Right: The Imperial Airways head office in Victoria, opened in 1939 just before war was declared and civil aviation suspended. It is now occupied by the National Audit Office.

Ships

The great ocean liners had become grand floating hotels in the Edwardian era. However, the sinking of the 'unsinkable' *Titanic* when it hit an iceberg on its maiden voyage across the Atlantic in 1912 and the torpedoing of the *Lusitania* a by a German submarine during the First World War threw doubt on their safety and security. In the inter-war years international competition was played out through the development of faster, safer and ever more luxurious liners, particularly on the North Atlantic crossing between Europe and North America.

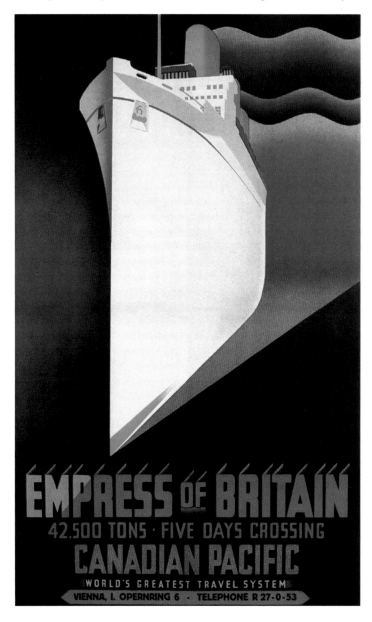

An art deco look was particularly suited to shipping posters. This design for the *Empress of Britain* was produced by the Clement Dane studio in 1932. (Getty Images)

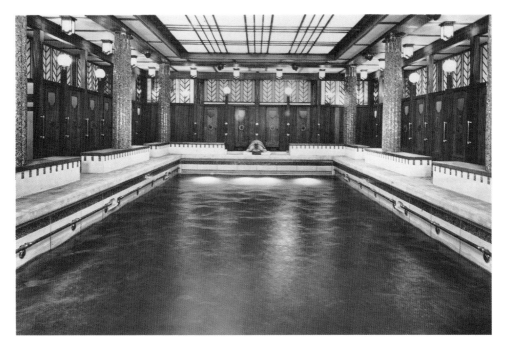

Art deco Olympian pool on the Canadian Pacific liner *Empress of Britain*, 1931.

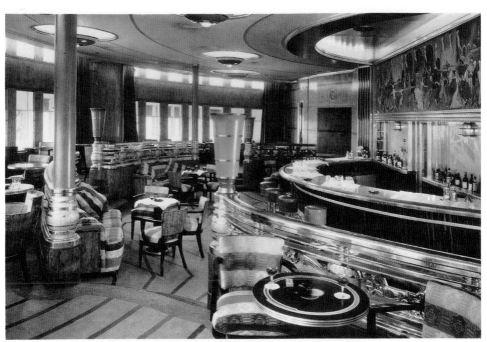

CABIN OBSERVATION LOUNGE & COCKTAIL BAR. R.M.S."QUEEN MARY."

The streamlined Cabin Observation Lounge and Cocktail Bar of the *Queen Mary*, 1936.

Britain's major new liners of the 1930s, the *Queen Mary* and *Queen Elizabeth,* were direct responses to the commercial threat posed by the German *Bremen* and *Europa,* launched in 1929/30, and the French liner *Normandie,* scheduled to arrive in 1935. Cunard also needed to replace its ageing trio of liners built before the war, the *Mauretania, Aquatania* and *Berengaria,* the last acquired as war reparations from the German Hamburg-America Line.

Design and marketing played a growing part in persuading people to travel and make a long journey at sea a pleasant and enjoyable experience. Celebrated poster designers produced some of their most alluring images promoting the latest glamorous ships and these were backed up by numerous magazine and newspaper features that boasted of their size, speed and technical prowess.

Although Cunard's flagship the *Queen Mary* is often said to have an art deco interior design, the liner does not really have a close affinity with modernism. Cunard was a conservative company and unlike the ultra-modern French liner *Normandie,* the shape of the ship stayed close to its predecessors and was not innovative. The decision to employ a wide range of craftspeople and artists on the interior design work was a promising co-operation between art and industry but it was not closely co-ordinated. There was little consistency in the ship's overall interior design and decoration, which ranges widely in style from the classical to the avant garde, but the *Queen Mary* was a very popular ship. The modern design community in Britain showed much greater enthusiasm for the work of New Zealand-born marine architect Brian O'Rorke, who gave two new passenger ships commissioned by the Orient line, the RMS *Orion* (1934) and *Orcades* (1937), a beautifully co-ordinated contemporary appearance.

Did you know?

The great ships were seen as floating ambassadors of national achievement and the story of the *Queen Mary* in particular, planned in 1930 as the Cunard line's largest modern liner, was promoted as a symbol for the whole country in the struggle to overcome economic depression. Work on what was Hull Number 534 at Clydebank, Scotland, was halted in 1931 after a year because of the financial situation following the Wall Street Crash. Construction only resumed three years later with government funding and the forced merger of Cunard with the White Star Line, its main rival. Great play was made of the contribution to the giant ship's completion that came from all over the country. Beyond her crucial importance to the Clyde shipyards, she was famously to be an 'all-British' ship, relying on suppliers and manufacturers from more than sixty towns and cities in Britain, and woodwork decoration from across the British Empire. Her maiden voyage to New York on 27 May 1936 was tangible evidence of the end of the Depression and of faith in the future.

Sadly the *Queen Mary* is the only one of the great inter-war liners to survive, but not in Britain where she was built. Rather incongruously, since decommissioning in 1967 she has become a floating hotel in Long Beach, California, a destination she never served.

8
Art Deco Past and Future

Arguably the last art deco building in Britain was not opened until 1950, and was demolished in 1980. This was the Ocean Terminal at Southampton, built to serve passengers arriving by train to board a ship and vice versa. The curved, streamlined design looked absolutely right to serve the great pre-war liners but seemed stylistically marooned in another era, and the retro design was severely criticised. In the post-war austerity years, when the priority was reconstruction, both art deco and streamlined moderne suddenly felt like looking back to the past. Ironically, what had been sold as the future was now inappropriate and the new world was going to look very different.

Pre-war art deco and modernist buildings went into slow decline in the 1950s and '60s, unfashionable and unappreciated. The first revival of interest in the style, and the first use of the term 'art deco' came in the 1960s, popularised by Bevis Hillier's book *Art Deco of the 20s and 30s* in 1968. A few museums, notably Brighton and the V&A, began collecting decorative pieces such as furniture and ceramics, but by the 1970s complete interiors such as cinemas and hotels were being ripped out, while many industrial buildings saw a change of use, demolition or were savagely altered and modernised. There were a few early 'listings', for example of selected Holden stations on the London Underground, but a growing number of art deco buildings were clearly at risk.

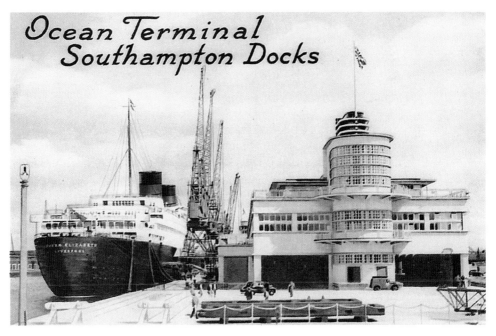

The Ocean Terminal at Southampton, opened in 1950, was a post-war exercise in deco that seemed out of time. This postcard view shows Cunard's *Queen Elizabeth* moored alongside in the early 1950s. The terminal was demolished in 1980.

The Thirties Society was formed in 1979 to campaign for the care and preservation of the best post-1914 buildings, taking over chronologically where the Victorian Society's work ended. In the same year the Arts Council held the Thirties exhibition in the Hayward Gallery, the first to look at art and design of all kinds in the pre-war decade.

Within a year the Thirties Society's first serious high-profile case arose with the threat to the 1928 art deco Firestone factory on the Great West Road. The building was demolished by its owners over a bank holiday weekend in August 1980 in anticipation of its being listed. This was a seminal moment for the Society and gave a sudden publicity boost to its work. By 1992 it was decided to rename the group the Twentieth Century Society, which now campaigns more widely for the preservation and care of post-1914 architectural heritage, deco or not. The society now has a thriving programme of talks, visits and activities around the country organised through its regional groups. For membership details visit c2oSociety.org.uk.

Many art deco and moderne buildings are still under threat of demolition or redevelopment but there have been a growing number of successful listings and restoration projects in the twenty-first century, many of them assisted by grants from the Heritage Lottery Fund. There are currently two particularly encouraging conservation schemes underway at opposite ends of the country: Saltdean Lido in Brighton, which reopened after initial renovation in 2017 but is an ongoing project, and Rothesay Pavilion on the Isle of Bute, Scotland, scheduled for completion in 2019. Hopefully, both of these much-loved but sadly neglected art deco gems now have a very positive and useful future ahead of them. You can follow their progress on saltdeanlido.org and rothesaypavilion.co.uk.

The art deco gates are all that remain of Wallis, Gilbert's Firestone factory on London's Great West Road, controversially demolished in 1980 before it could be listed for preservation. The building beyond is its bland office and warehouse successor.

9
What Now?

Exhibitions, conservation and restoration of objects and buildings from the brief heyday of art deco and early modernism have blossomed in recent years. This brief introduction concludes with suggestions for further information, places and museums to visit. Please note that there is no public access to most privately owned properties, though special permission may sometimes be obtained for a visit.

Museums and Galleries

All the museums listed here have some art deco and modernist collections, but they are not always available or on public display. The Victoria & Albert Museum (V&A) in London has the best decorative art collections in the UK and particularly useful online information on both topics. The London Transport Museum has its entire poster collection, including many deco images, available online. Please check access, opening hours, special exhibitions and activities on all these websites before visiting in person.

Brighton Museum: brightonmuseums.org.uk
Brooklands Museum, Weybridge: brooklandsmuseum.com
Design Museum, London: designmuseum.org.
Isokon Gallery, London: isokongallery.co.uk
London Transport Museum: ltmuseum.co.uk
Museum of Domestic Decorative Art & Design (MoDA), London: moda.mdx.ac.uk
National Motor Museum, Beaulieu: beaulieu.co.uk
National Museum of Scotland, Edinburgh: nms.ac.uk
National Railway Museum, York: nrm.org.uk
V&A Museum of Design, Dundee: vandadundee.org
Victoria & Albert Museum (V&A), London: vam.ac.uk
Walker Art Gallery, Liverpool: liverpoolmuseums.org.uk/walker
78 Derngate, Northampton: 78Derngate.org.uk

Websites

Modernism-in-metroland.co.uk
Modernistbritain.co.uk
c20Society.org.uk

Publications

This is a short reading list for those seeking more information on art deco and modernism in Britain. The two exhibition catalogues published by the V&A are both detailed hefty tomes with international coverage. Bayer, Powers and Tinniswood are all recommended on architecture, with excellent photographs. Buckley puts art deco and modernism in the wider context of British design in the twentieth century. Davidson is an enthusiastic guide to art

deco and related sites all over Britain, and the fact that Butler has found so much surviving streamline in Worcestershire alone suggests that there is a lot more waiting to be discovered well outside London and the South East, which do not have a monopoly on modernism!

Arber, Katie, *Home Decoration and Furnishing from the 1930s* (MoDA, 2015).

Artmonsky, Ruth, *Austin Cooper, Master of the Poster* (Artmonsky Arts, 2017).

Benton, Charlotte, Benton, Tim & Wood, Ghislaine (eds), *Art Deco 1910-1939* (V&A Publishing, 2003).

Bayer, Patricia, *Art Deco Architecture* (Thames & Hudson, 1999).

Buckley, Cheryl, *Designing Modern Britain* (Reaktion Books, 2007).

Butler, Phillip, *Streamlined Worcestershire* (Art Deco Magpie, 2017).

Cook, Patrick and Slessor, Catherine, *An Illustrated Guide to Bakelite Collectables* (Quantum Books, 1998).

Davidson, Genista, *Art Deco Traveller, A Guide to Britain* (Art Deco Publisher, 2016).

Duncan, Alistair, *Art Deco* (Thames & Hudson, 1988).

Finamore, Daniel & Wood, Ghislaine, *Ocean Liners* (V&A Publishing, 2017).

Gray, Richard, *Cinemas in Britain* (Lund Humphries, 1996).

Guise, Barry & Brook, Pam, *The Midland Hotel, Morecambe's White Hope* (Palatine Books, 2009).

Haworth-Booth, Mark, *E. McKnight Kauffer, a Designer and his Public* (V&A Publishing, 2005).

Heller, Steven, *Euro Deco* (Thames & Hudson, 2004).

Knowles, Eric, *Art Deco* (Shire Publications, 2004).

Miller, Judith, *Miller's Art Deco* (Octopus Publishing Group, 2016).

Mullay, A. J., *Streamlined Steam, Britain's 1930s Luxury Expresses* (David & Charles, 1994).

Peto, James & Loveday, Donna (eds), *Modern Britain 1929–39* (Design Museum, 1999).

Powers, Alan, *Modern: The Modern Movement in Britain* (Merrell, 2005).

Schwartzmann, Arnold, *London Art Deco* (Palazzo Editions, 2013).

Steele, James, *Queen Mary* (Phaidon, 1995).

Stevenson, Greg, *The 1930s Home* (Shire Publications, 2000).

Tinniswood, Adrian, *The Art Deco House* (Mitchell Beazley, 2002).

Wilk, Christopher (ed.), *Modernism 1914-39: Designing a New World* (V&A Publishing, 2006).

Yorke, Trevor, *Art Deco House Styles* (Countryside Books, 2012).